Wicked Women

of NORTHEAST OHIO

Wicked Women

NORTHEAST OHIO

JANE ANN TURZILLO

Charleston — London

THE
History
PRESS

Published by The History Press
Charleston, SC 29403
www.historypress.net

Copyright © 2011 by Jane Ann Turzillo
All rights reserved

First published 2011

Manufactured in the United States

ISBN 978.1.60949.026.3

Library of Congress Cataloging-in-Publication Data

Turzillo, Jane Ann.
Wicked women of northeast Ohio / Jane Ann Turzillo.
p. cm.
Includes bibliographical references.
ISBN 978-1-60949-026-3
1. Crime--Ohio--History--Anecdotes. 2. Female offenders--Ohio--Biography--Anecdotes.
3. Women--Ohio--Biography--Anecdotes. 4. Ohio--Biography--Anecdotes. 5. Ohio--
History, Local--Anecdotes. 6. Ohio--Social conditions--Anecdotes. I. Title.
HV6793.O3T87 2011
364.1092'27713--dc22
2011002397

This book is dedicated to my mother, Lucille Turzillo (1915–2007).

Angel face and heart of a demon.
—*Jack L. Brizzi Jr. (1976–2010), "It Has Happened"*

Contents

Acknowledgements

All of the people who helped me put this book together deserve my utmost gratitude. Without them, there would be no *Wicked Women of Northeast Ohio*.

First and foremost, I'd like to thank my editor, Joe Gartrell, for coming up with the idea and helping me fine-tune it.

I am deeply indebted to the librarians who assisted with my research: Jean Adkins, Massillon Public Library; Deborah Kitko, Wayne County Public Library; Cynthia Gaynor, Reed Memorial Library; Lynn M. Duchez Bycko and her intern, Eden Kovacik, Cleveland State University, Michael Schwartz Library; Judy James and staff, Akron Summit County Public Library; Carol Genova, Warren–Trumbull County Public Library; and Mary Carey and staff, Stark County District Library. They all helped me search through old newspapers, hanging files, census records, history books, death records and penal records in order to find interesting women to write about.

Research assistants Dan Ackerman in Wayne County and Marilyn Strubble in Ashtabula County have my thanks. They were a huge help and saved me a lot of time.

Matt Lautzenheiser, director of the Dover Historical Society and J.E Reeves House, sent me photos of Ellen Athey and Mary Seneff. Fred Miller,

ACKNOWLEDGEMENTS

Tuscarawas County Historical Society, dug out newspaper articles for that chapter. Sincerest thanks to both of them.

Thanks to Chris Cefus, Larry Fischer and Barbara Petroski, who spent considerable time helping me hunt through the Portage County Historical Society files and photos.

I also want to thank Barb Steel and Marcie Rehard of the Wayne County Microfilm Department for copying the large murder trial file of Enola Morehouse for me.

Rudy Turkal came through with three Massillon photos for this project. My artistic friend and co-worker, Justin Campbell, did two fine illustrations for me. Lou and Bonnie Janelle of LBJ Photography helped get all the photos and illustrations ready for the book. Many thanks to all of them.

When it comes to research, Gwen Mayer, Hudson Library and Historical Society, always heads me in the right direction. Betty Mortiz provided some much-needed historical background of the Niles area. Roger DiPaolo pointed me toward information in Kent.

The encouragement from my friends and co-workers has meant a great deal to me.

Thank you to my sister, Mary Turzillo, for reading and commenting on my manuscript.

This book was also made possible by all those period journalists whose bylines did not appear on the stories they wrote for the local and regional newspapers.

Finally, I want to thank the rest of my family: my son, John-Paul Paxton; his wife, Kindra; and Nicholas and Nathan, for their love and support through this project. Jack, I wish you were here to see it finished. We miss you.

To all of the above, again, my heartfelt thanks.

Introduction

Historically, the world of crime has been dominated by men, so when a criminal act is attributed to the fairer sex, the story is all the more fascinating. It makes front-page news, and a curious public clamors for a peek into the life of the wicked woman who committed the act.

Meet ten women who secured their places in northeast Ohio's history by committing some of the most sensational crimes of their day. A few of the women in these pages perpetrated their deeds because they were truly wicked. But at least two of them were driven into their wrongdoings. Questions still go unanswered in a couple of cases. If these women had one characteristic in common, it was that they were desperate.

Philandering lovers pushed Annie George and Sarah Robinson to the brink. In Sarah's case, we know she plugged her sweetheart with a .38. She admitted it. But Annie denied killing her beau even though she had threatened to fill him full of lead. A jury considered the evidence in the case and acquitted her of the murder.

Rose Tauro was bound by a promise to avenge her husband's death. She carried out that promise with a gun in one hand and her child in the other. "Akron Mary" Outland Woodfield sought excitement and found it with the wrong man. Her love for a small-time hood landed her in the middle of a murder investigation and made her the target of a police search.

Ardell Quinn was a smart businesswoman, the proprietor of the longest-running brothel in Cleveland until Eliot Ness came calling at her door.

Marguerite Carlile was accused but never tried for the murder of her husband, a former sheriff. Police were certain she was guilty, but the evidence was lacking. Still, almost eighty years later, no one has answered for that crime.

Axe murderess Ellen Athey was totally unbalanced, truly mad. Jealousy overruled reason when she hacked her housekeeper to death. Velma West bludgeoned her husband to death and then went out to play cards. It is likely that she lacked a conscience.

Today, Jeanette McAdams and Enola Morehouse would be labeled as serial killers. Both committed particularly heinous murders. While Jeanette poisoned six members of her family, Enola used an opiate to do away with unwanted babies.

I hope you enjoy reading the stories of these women and their crimes as much as I enjoyed researching and writing about them.

Sarah Robinson

S itting in her jail cell, Sarah Robinson was almost gleeful that she had shot and mortally wounded the man she loved. With no chance to make the $2,000 bail, the cocoa-skinned woman pleaded guilty to shooting with the intent to kill at her arraignment. "I oughta give him a second shot," she told a reporter for the *Massillon Independent* on Tuesday, April 15, 1902. "I oughta plugged him once more. That'd fix it."

Her sweetheart was the darkly handsome Walter McNair, and the six-foot, broad-shouldered, sinewy "King of Honky-tonk" was a hit with the ladies. They called him well spoken—clever even—and always well dressed. In turn, he paid way too much attention to other women, as far as Sarah was concerned.

McNair kept a saloon in a story-and-a-half old frame building on the corner of South and Canal Streets, and Sarah helped him. It was in an area near the canal in Massillon called Smokey Hollow. The saloon was frequented by people who worked at the Massillon steel plant, many of whom had followed McNair from Cincinnati. By all accounts, it was a wretched place. Paint was peeling from the walls and plaster was crumbling off the ceiling. Grime covered the floor. A large store box served as a table, and smaller boxes were used as chairs. Near the saloon stood an old stone

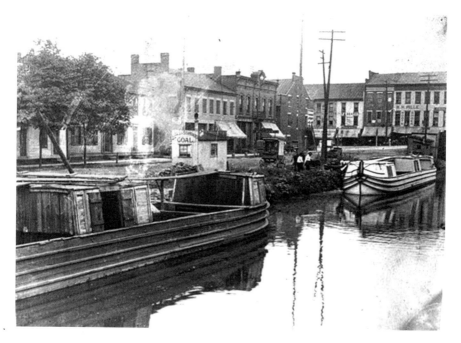

The Ohio & Erie Canal along Canal Street in Massillon, circa 1900. *Courtesy Rudy Turkal.*

house, known as the "king's castle," where Sarah lived with McNair on the first floor. The upstairs was rented to a white woman named Mrs. James and her two daughters.

Sarah was consumed with jealousy of McNair's attention to the white women upstairs when she entered the saloon from the back door on that Monday afternoon. She went behind the bar, and as McNair was drawing a beer, she picked up his revolver and hurried to the front door. Before exiting, she turned to face him. She drew the gun from under her apron, aimed and pulled the trigger, sending a piece of .38-caliber lead into his chest.

She dropped the gun and bolted out the door and down the alleyway to another neighborhood saloon. She begged the owner, Nicholas Schneider, to conceal her. He could see she was agitated, and he asked why she wanted to hide. Was she in some kind of trouble again? At that point she attempted to pull herself together.

"No," she said, "there's no trouble exactly. I've shot my sweetheart; that's all. Did I say I wanted to be hid? I musta been crazy, I don't want to hide. Send for a policeman. I want to go to jail."

Schneider lost no time in sending for the police. Three police officers, Ernest Wittmann, Turinne Getz and Officer Brownsberger, got word from different sources and converged at Schneider's saloon. As they took Sarah away, she laughed and joked with them, saying she had never felt so joyful. "Walt will never appear against me."

The next day's edition of the *Massillon Independent* called twenty-one-year-old, deep maroon–eyed Sarah the "Dusky Belle of Smokey Hollow"; her thirty-four-year-old lover was dubbed a "Black Adonis." The story occupied a space on the front page of the newspaper for several days.

It seems as though Walter had his hands full with his many love interests. In addition to his affair with Sarah, he had a wife and child in southern Ohio, though the 1900 census showed he was divorced and living with a housekeeper, Anna Williams. Miss Williams, who was originally from Georgetown, Kentucky, had apparently been elevated to fiancée in his affections.

"I knew that Walt was writing letters to a woman named Williams right along," Sarah said Tuesday evening. "And that he didn't care for me anymore, and then all I wanted to do was to get away, but he wouldn't let me go."

Weeks before the shooting, Sarah had been accused of stealing eighty dollars from a man named Robert Hammond of Massillon. Part of that money was recovered. Sarah complained that McNair would not give her any money. She would have left him if he had given her enough money to get back home to Addyston.

Sarah had put up with quite a lot. A friend recalled that McNair was always popular with the women in the circles in which he moved in whatever city he lived and that he never seemed to be happy unless he was involved in some type of "entanglement of a sensational character."

McNair made his fatal mistake when he began outwardly flirting with the white women who lived upstairs. Rumor had it that he had been intimate with one of them. He even went so far as to tell the light-skinned Sarah, "I'm going to get me a white girl; you're too dark for me." A short time later, he was seen coming from the white woman's apartment.

Sarah brooded for days until jealousy clouded rationality. "He's done enough to me in the last six months to go to penitentiary a dozen times. When we was down in Addyston, Walt and me was all right. We lived there four years," she said.

"I met Walt the first time five years ago away down in Tennessee," she told authorities. Sarah abandoned her husband to run off with McNair but kept her married name. The husband may have been well rid of her, as he made no attempt to come after her.

McNair conducted a saloon in Addyston, a town a few miles west of Cincinnati close to the Ohio River. Sarah ran the saloon while McNair, a brick maker by trade, worked in a steel plant. They moved to Massillon just six months before the shooting.

"I used to think that Walter always thought most of Sarah," said Monroe Hooper, a close friend of McNair. "Down in Addyston, when we was all down there, there wasn't nobody that could take the place of Sarah. And she was good to him."

Hooper recalled how Sarah got up at three o'clock in the morning and, without any help, fixed breakfast for from five to eight of NcNair's friends so they could get to the steel plant on time. She would keep on working all day, often until late at night, tending bar, cleaning and doing anything else to keep the saloon running. "I'd know of lots of cases she'd stay up all night, looking after Walter's business, and keep right on going the next day, working hard," Hooper said.

At just five feet, five inches and about 140 pounds, Sarah was described as comely, bordering on the octoroon. She had a tattoo of a heart with rays, five-pointed stars and a spread eagle on a shield on her right forearm.

"I never know'd her to get jealous till this talk came out about Walt having a white girl," Hooper said. "That's what made most of the trouble, I think."

Sarah told Mayor J.J. Wise and her jailers conflicting stories about the shooting. In one account of what led up to the shooting, she said that since they had come to Massillon, a year earlier, they had been having trouble. She claimed McNair did not treat her "right." They had a fight the Thursday night before the shooting. She had been uptown, and when she got back McNair "kicked" her around and then locked her up in a room.

"All the time since then we've been having it," she said. The way Sarah saw it, McNair had been paying too much attention to other women, especially white women. Then on Monday she heard he was with a white woman again. That's when she made up her mind to shoot him. She knew where he kept his gun. "I went right straight to the saloon without thinking anymore about it, and I did the best I could. But I oughta killed him."

As McNair lay on his deathbed, Mayor J.J. Wise took his statement. His account of the shooting insisted that Sarah had grabbed the gun from his pocket. Witnesses said she got it from behind the bar. Sarah told a totally different story to authorities. She claimed they were talking about shooting in the bar. She told the men that she could "shoot as well as anybody," and McNair replied, "No one would be afraid of your shooting," and set the revolver on the bar. She picked up the gun, walked to the door, turned and fired.

Whatever way it happened, McNair did not want to have Sarah turned over to authorities. Boarders at McNair's stone house said he almost seemed to believe he deserved what he got. He seemed to feel worse about what might happen to Sarah as a result of the shooting than his own condition. But then, he did not feel he was dying.

The Reverend J.E. Transue, pastor of the African Zion church, came to give McNair spiritual support and possibly relieve his conscience, but the dying man would not express any "remorse for the past nor fear for the future."

In fact, McNair was certain he was going to recover. Just twenty minutes before he died, he asked for a drink of water. He told his brother, William, who had come up from Addyston, that he was resting comfortably. A short time later he took a turn for the worse and became weaker. Dr. Findley and McNair's brother stayed by the bedside. Although McNair never lost consciousness, he gradually slipped away at 8:20 Wednesday morning.

A story floating around was that Walter McNair had property worth $10,000 down in Addyston. Mayor Bernard Bell and Marshall Kitchen also heard that the murdered man had $400 in cash, although no trace of any money was found. William McNair asserted that all the money he had was $28 given to him by the bartender, and he could not even pay the doctors who had attended his brother. He told Bell and Kitchen that he and his brother together did not have $400, let alone $10,000. Truth was, his brother was so deeply in debt that everything in the saloon, as well as the furniture in the living quarters, including a piano, was mortgaged for more money than it would bring at sale.

An autopsy was performed later that same day. Coroner H.M Schuffell said the bullet had penetrated the bone and "passed through the pericardium, the sack around the heart, through the fatty tissue of the heart and from there through the right lobe of the lung at the apex." The damage to the

heart probably would not have been fatal, but hemorrhaging in the lungs caused his death.

Miss Anna Williams, the purported fiancée from Georgetown, Kentucky, had arrived in Massillon on Wednesday night, just in time to accompany William McNair and his brother's body back to Addyston for burial Thursday.

Sarah was not immediately told of McNair's death. She occupied her time by reading novels and did not seem to be the least bit troubled. She did not even ask about McNair's condition.

On Thursday, Sarah saw a newspaper for the first time and read that the man she loved—the man she had shot—had died. All along she had believed her sweetheart would survive and that he would not testify against her. "I did not mean to kill him," she said morosely. She quit eating and lapsed into silence except to finally ask to consult an attorney.

Friends brought her some articles from home and tried to visit her, but Sheriff McKinney, under orders from the prosecutor, refused to allow her any visitors except her attorney.

On May 12, the grand jury in Canton returned a true bill against Sarah Robinson for the first-degree murder of her paramour, Walter McNair. The case was assigned to Judge R.S. Ambler's court.

While the Stark County prosecutors Robert H. Day and C.C. Bow got busy preparing for trial, Sarah's attorneys filed motions asking for dismissal. Among their legal maneuvers, Attorneys A.M. McCarty and Dan W. Shetler contended that the presence of the court stenographer, Belle H. Norwood, in the grand jury room removed the secrecy of the deliberations. The problem was that, although the prosecutor had requested a stenographer to be present, the order for a court stenographer had not been entered into the official record. Judge Ambler took a few days to look at the statutes and mull over the matter. In the end, he found that taking testimony during the grand jury proceedings could not in any way be prejudicial to Sarah Robinson's interests. He then had the record changed to show the order for the stenographer.

Jury selection took the better part of three days. Because it was a death penalty case, Sarah's attorneys were careful to weed out any potential jurors with prejudices or preconceived ideas. The first jury pool of thirty-six men was exhausted, as was the first special venire of twelve men. It took a second special venire before the full jury was seated.

Sarah Robinson

The Canton courtroom had become so crowded with spectators that the judge moved the proceedings to a larger courtroom, which also became packed.

In their opening statement, the prosecutors said they intended to show bad feelings between Sarah Robinson and Walter McNair growing out of his attention to the white women who lived upstairs. They said she was jealous and had made threats against his life.

Prosecutor Day told the jury, "We expect to show that this woman threatened to kill McNair and that she did kill him in a premeditated and deliberate manner." He had subpoenaed about thirty witnesses to help prove the state's case.

Defense attorneys McCarty and Shetler claimed Sarah Robinson shot her lover in self-defense and that she feared for her own life. They said she was not guilty of murder in the first degree or any other crime. They had subpoenaed about thirty witnesses to prove it. "The testimony will disclose that he ruled everyone about him, including the defendant, with a high hand; that he walked around his saloon with two revolvers, one in either hip pocket."

The defense maintained that immediately before the shooting, McNair was outside behind the saloon and Sarah was inside the building. She sent word asking him to come in. He said he would come in when he was good and ready. Sarah went out and personally asked him to come in. "He knocked her down and abused her shamefully remarking, 'You d---d b---- go back in there and stay where I tell you or I'll kill you now.' He compelled her to go back into the bar with him," McCarty told the jury in his opening statement. Once inside, Sarah picked up the revolver from behind the bar. Another gun lay underneath the counter where the beer glasses were kept. Someone asked Sarah to close the door. "McNair spoke up and said 'You d-- b---- if you don't shut the door, I'll shoot you,' and he reached down to where the revolver lay."

After the opening statements, the twelve jurors boarded the 12:50 p.m. interurban train to Massillon to view the scene of the shooting. Sheriff McKinney pointed out the spots that would figure into the testimony, and they followed Sarah's flight to Nicholas Schneider's saloon.

After the jurors returned from "Honky-tonk" in Massillon, the prosecution witnesses began testimony. Frederick Hose of Massillon recalled a conversation with Sarah a few days before the shooting. "I heard her say

that if he [McNair] did not keep away from the white trash she would blow his lights out."

Hose's daughter Minnie Shearer testified that a week before the shooting Sarah told her that if "Walter did not quit flirting with the white women she would blow his brains out." Under cross-examination, the woman admitted that she and Sarah were on bad terms and had quarreled two weeks before the shooting and had not spoken since.

The next morning found William McNair seated next to Prosecutors Day and Bow.

Daniel Epps, a resident of McNair's boardinghouse and patron of his saloon, was the first to take a seat in the witness box. He said there were four other men in the saloon at the time of the shooting. "I was seated on a beer case near the stove when the trouble began. McNair was behind the bar drawing a glass of beer for Cy Young. Sarah went behind the bar and got a glass of beer. Then she walked around in front of the door. She opened it. A shot rang and I turned around. She stood there with a revolver in her hand. McNair was drawing a glass of beer at the time. He said 'I am shot' and fell. I jumped from the beer case and by this time Sarah had thrown the revolver on the floor and started away."

Under cross-examination, Epps told the court that Sarah came into the saloon ten or fifteen minutes before the shooting. He said to the best of his recollection, McNair had not been out in the backyard. Defense attorneys got him to admit that he had served a year in the penitentiary for shooting an Italian, but the defense attorney contended it was for stealing a horse.

The next prosecution witness, Harvey P. Walton, corroborated many of the details of Epps's story. He saw the revolver on the back bar near the cash drawer. Although he heard the gun go off and saw Sarah run, he did not see her fire. According to Walton, before the shooting, Jim Green asked why she did not close the door. McNair called out to her, "Habit [sic], shut the door." She replied, "I will in a minute."

When McCarty approached the witness, Walton said he remembered that McNair left the saloon for a short time and returned a few minutes before the shooting.

Next on the stand were the policemen called to Schneider's saloon after the shooting. Turinne Getz, one of the Massillon policemen who arrested Sarah, told the court that when he first asked her if she shot McNair she said, "No."

"I asked 'Where is the revolver?' She said, 'I have no revolver.' Then I told her she would have to go to the police station. We started out with her. I accompanied her to the house to get her clothes. She made no effort to get her clothes and I took her along."

On the way to the lockup, he asked her again if she shot McNair. "She replied that she had shot him and she hoped he would die."

The defense objected to the remark and wanted it stricken. The court recessed for five minutes while Judge Ambler mulled over the line of questioning. When he reconvened court, he overruled the defense's objection and let the testimony stand.

Patrolman Ed Ertle of the Massillon Police Department was next to testify for the prosecution. He, Prosecutor Day and Patrolman Ernest Wismar had a conversation with Sarah at the city lockup on the night of the shooting. When they asked her why she shot McNair, she said, "I did not shoot him. He shot himself."

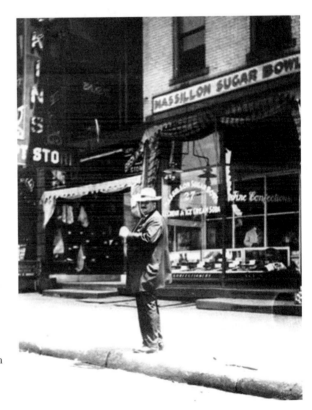

Police Chief Ed Ertle in front of the Sugar Bowl on Main Street (now Lincoln Way), circa 1914. *Courtesy Rudy Turkal.*

Ertle, who in later years became Massillon's police chief, testified that Mayor J.J. Wise asked Sarah a similar question a short time later. This time she admitted shooting him and stated that if she thought she had not "fixed" him the first time, she would have gone back and shot him again.

Wismar corroborated Ertle's testimony and recalled that Mayor Wise cautioned Sarah that she better tell the truth. It was then that she admitted to shooting McNair. She said it was her first intention to shoot him in his sleep, but she changed her mind.

The defense attorney put both Ertle and Wiseman through rigid cross-examination. When he could not shake either of the witnesses, he objected to the introduction of the testimony but was overruled again.

From there, the prosecutor called Victor Morgan, an *Independent* reporter who interviewed Sara at the jail, and Officer Wittman, who witnessed that interview. Next called was Nicholas Schneider, who owned the saloon where Sarah tried to hide after the shooting. A number of other witnesses took the stand, and their testimonies were all unfavorable to Sarah.

With the evidence mounting, McCarty and Shetler apparently realized it was futile to try to get an acquittal for their client. Because the death penalty loomed over Sarah's head, they decided it was best for her to plead guilty to manslaughter, a verdict that carried from one to twenty years. Sarah took their advice and pleaded guilty in a clear voice with no hint of tremor.

Prosecutor Day said, "The circumstances were such that I hardly felt justified in continuing the case. We would not have gotten better than second degree murder and the chances were that a verdict of manslaughter would have been returned."

In the Friday, July 18, 1902 edition, the *Massillon Independent* informed its readership of how much money this plea bargain would save. "By permitting her to do this a considerable amount of expense is saved, as the case would surely have continued till the latter part of next week. The jury costs $24 a day, there were between thirty and forty witnesses at $1 a day each, the attorneys' fees would be all the greater and the court costs generally would have been paid."

The paper also congratulated the prosecutors. "Prosecuting Attorney Day and his associate C.C. Bow have worked hard, and the mountain of evidence which they erected during the first few days of the trail is what brought the case to so abrupt an end."

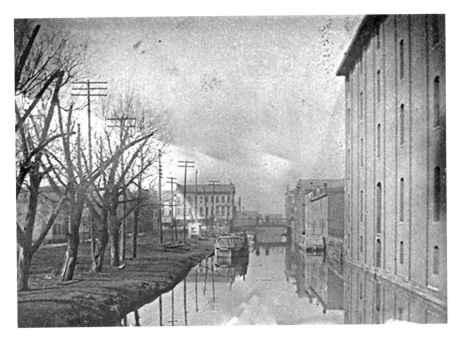

The Ohio & Erie Canal looking north from Tremont, circa 1898. *Courtesy Rudy Turkal.*

Shetler and McCarty insisted that before the sentence was pronounced important defense witnesses be heard to show fear and provocation on Sarah's part. On Saturday, Sarah's witnesses were heard. Their testimony showed that McNair had threatened Sarah. Witnesses testified that there was a revolver on the work board where the glasses were kept under the bar and that it looked as if he was reaching for it at the time of the shooting. McCarty also filed several affidavits in connection with the case.

A week later, after reading all the affidavits, Judge Ambler sentenced Sarah to seventeen years at hard labor in the Ohio State Penitentiary without solitary confinement.

Sarah was received at the penitentiary July 30, 1902. She was released on parole April 12, 1906.

Chapter 2

Ardell Quinn

Cleveland's Vice Queen

April Fool's Day 1932 was no joke to Ardell Quinn when Cleveland
Police Captain Louis Cadek and two plainclothesmen from the
Eleventh Precinct raided her exclusive bordello, known as the Hollywood
Royal Club. The private club was familiar to police and patronized by
local politicians and successful businessmen for the better part of twenty
years.

It was right around midnight when the cops landed on Ardell's 1916 East
Eighty-fourth Street doorstep with a warrant authorizing them to search for
liquor. The lights were out in the three-story house, and no one answered
the knock at the door. After waiting about fifteen minutes, one of the cops
gained entrance by crawling through a basement window and then letting
the other two in.

Cadek, who was later convicted of taking bribes in a different matter,
found no liquor, but he and his officers did find Ardell, dressed in a bathrobe,
holding court with four men sitting around the dining room table. Five more
women were found in the many rooms upstairs.

Ardell told police that the men and women had just stopped by to pay
a visit. Police did not buy it. They arrested Ardell and the five ladies who
occupied the second floor. The women gave their names as Cleo Horton,
twenty-five; Catherine Schultz, twenty-two; and Marie Buell, twenty-five—

all three manicurists, perhaps recruited from Ardell's beauty school. The other two women were Margaret Mason, twenty-five, a bookkeeper; and Louise Shepard, forty-six, a widow. The men were not arrested. It seems as though there was a double standard in those days.

After a lecture from Police Chief George J. Matowitz the following day, Ardell signed a waiver admitting that she operated a vice resort. Each of the other five women signed a waiver admitting that she occupied a room in the house to use for immoral purposes. All of them were released. Four of the women were escorted out of Cleveland and told not to come back. The fifth woman was allowed to stay in the city because she had employment, but she was told to stay away from the East Eighty-fourth Street house. Ardell had to promise not to receive visitors again.

Matowitz was an honest, ineffectual cop known to issue platitudes. He declared that the "joint" was closed and would stay closed. Deputy Police Inspector Martin J. Horrigan thought they had struck a blow against vice in the city. But they did not know Ardell Quinn. Promises were made to be broken.

The "joint," as lawmen referred to it, was an exclusive club decorated in opulence with rare antiques, fine oil paintings on the walls and luxurious Oriental rugs on the floors. The ornate furnishings were expensive and equally tasteful. The heavy brocade drapes were always closed to assure maximum privacy. Ardell's patrons were fond of saying, "Ardell had class."

Ardell was fond of saying that she was born in France and that she was of French and Spanish blood. She even spoke with a French accent. In truth, she was born in 1894 in Zahle, Lebanon. She and an older sister, Naza, were the daughters of a wealthy merchant, Habeeb Bojde.

Naza ran away from home with her young husband to America. In 1904, when Ardell was old enough, she immigrated. At some point, she landed in Buffalo, where in 1915, she met and married Arthur Quinn, a railroad brakeman. Within the next five years, they had moved to Cleveland to be closer to Naza. Classifieds in the *Cleveland Plain Dealer* announced that Ardell opened a beauty school on Euclid Avenue. The ads read, in part, "first-class teacher; diplomas given." Young women as far away as Sandusky entered Madame Ardell Quinn's Beauty Shoppe for a three-month training period. Later on, it became evident that some of the "roomers" at her exclusive club were recruits from her beauty school.

Ardell Quinn operated the Hollywood Royal Club, a Cleveland vice resort, for twenty years. *The Cleveland Press Collection, courtesy of CSU Michael Schwartz Library, Special Collections.*

Three weeks after signing the waiver in Cleveland admitting that her house on East Eighty-fourth Street was a vice resort, Ardell fell into disfavor with South Euclid authorities.

She had rented a twenty-room, well-secluded house on Donwell Drive and Belvoir Boulevard. It was set on a hill amidst trees on an acre of land, the perfect setting for Ardell. Marble walls and a grand ballroom gave it the aristocratic air she favored. There was a stained-glass window of a scene of old Jerusalem overlooking the entrance to the living room.

The house belonged to Joseph Harris, former vice-president of the South Euclid Republican Club. In the rental deal, Ardell signed twelve cognitive notes for $150 each for the year and then put out $1,500 for renovations and $7,000 for her trademark expensive furnishings.

About 150 of her "closest" friends received a silver embossed invitation to the opening of the new bordello. The announcement featured a four-part crest of a jug, musical notes, a plate of steaming food and a pair of women's crossed legs. Lovebirds, the head of Dionysus, Greek god of wine, and a map from the Cleveland house were also part of the graphics.

Wording on the announcement was flirtatious. "There is something of the country club here," it said in part, according to an article in the *Plain Dealer*. "Yet there is a charming lack of inhibiting formalities. Refreshments are reminiscent of a happier, more carefree age. Dining halls are available for larger parties, but there are also sylvan bowers for romantic tete-a-tete."

When South Euclid mayor Douglas G. Oviatt read in the paper of Ardell's "sylvan bower," he cut his vacation in Green Springs, Ohio, short to return to city hall. Marshal Jack Bilkey had a more live-and-let-live attitude toward Ardell, but Oviatt was determined to have the house closed down. He called the phone number in the newspaper ad and ordered her to come down to town hall and discuss just what her intentions were.

She obliged and showed up wearing a black dress and hat, a short white chinchilla jacket, dark brown webbed stockings and black pumps. Oviatt peppered her with questions about the wording on the invitation. When asked about it, she claimed she had nothing to do with "that invitation." It was an artist friend of hers who wrote it up. "Drop me dead if I knew what that coat of arms meant," she said in her French accent. "I've never had much schooling myself. I don't understand those big words.

"I leased this house when I got into trouble in Cleveland, and I just wanted to live there and make a little money on the side serving meals to some of my friends."

When the mayor asked if she intended to serve liquor, she replied, "Why of course not, mayor. I just want to live quietly." She insisted she wouldn't "even serve meals there until you give me the word, mayor."

"Why, I never got into any trouble in Cleveland until I couldn't identify Solly Hart as one of the men who held up my place several years ago." Ardell was referring to a robbery at her East Eighty-fourth Street house in late December 1927. Two men with guns relieved Mr. and Mrs. Fred Teusch of $1,950 in cash and jewelry. "Everybody had it in for me since," Ardell commented. Authorities believed that Solly Hart, who had mob credentials, had pulled the job. Ardell did indeed identify him as one of the two thugs before a grand jury in 1931. Harry Sherman was being sought as the second suspect at the time. Authorities could not find the Teusches.

As Ardell argued with Oviatt and city officials, she verged on tears and claimed that "everybody has it in for me."

As soon as the meeting broke up, Ardell invited the police and officials to "drop by any time."

Oviatt countered by saying, "We're going to watch you."

Ardell had hardly made it back to the house after the meeting when the mayor, Bilkey, the South Euclid solicitor and a reporter rang the doorbell. Inside they found the house to be comfortable and lavishly furnished but quiet and serene. In addition to Ardell, the advertising man who designed the invitation was there. So were two maids and the owner of the house. Two more young women were upstairs. Ardell claimed they were relatives.

Nothing seemed unlawful, but Oviatt warned Ardell that he was going to keep an eye on her. Every night the police kept Ardell's "sylvan bower" under surveillance. The officers were instructed to take license plate numbers of any cars that went to the house. Police reported that no one visited the house after midnight and that the lights were out around the same time.

The lease had a revocation "for cause" clause, and Joseph Harris decided to use it. He asserted that he had no idea of Ardell's reputation as the operator of a vice resort in Cleveland or her intentions for this house. He claimed she had leased the house under false pretenses for use as a private home when, in fact, her intentions were more prurient.

Instead of contesting the eviction, Ardell packed up and went home to East Eighty-fourth Street, where she again became a fixture in Cleveland nightlife.

A few months after returning to her Hollywood Royal Club, she filed for divorce from Arthur, charging him with gross neglect of duty. Although he lived just a few blocks away, he had not been a part of her life for the past three years. She insisted before the judge that she had behaved as a faithful wife and performed her marital obligations. They had no children. She claimed that from the beginning of their marriage on March 19, 1915, she was forced to work to provide for her own food, adequate clothing and other essentials, even though he was well able to support her. They had been living apart because it was "unbearable for them to live together." He had an uncontrollable temper, she claimed. She asked for her maiden name, Bojde, back in her prayer.

She told Judge Alva R. Corbett that she had been a hairdresser and she also furnished suites in an apartment house. She testified that at the present time she ran a rooming house. The work was hard, she claimed, and caused her to be weak and run-down. Her husband did not contest the divorce.

Ardell Quinn

After Ardell left court, an unknown man approached the judge with an invitation to visit Adell's house some evening. Judge Corbett was infuriated, ordering the man out of the court. He even weighed a possibility of contempt of court charges. He decided to withhold the divorce decree until he could investigate her. "At the time that case was tried, I had some doubts as to whether I should grant that woman's prayer for divorce. I have been making some investigations since that time, which are still going on, and I have not yet decided what to do."

Ardell apologized and claimed not to know the man or anything about the invitation. A month later, the judge reinstated the divorce decree.

The next time Ardell faced authorities was near the end of 1934, after Prohibition had ended. Her problem this time stemmed from her private club's liquor license. She appeared before the State of Ohio Liquor Control Board to fight having her liquor permit revoked for the Hollywood Royal Club.

The director, Colonel John A. Hughes, questioned Ardell as to whether she had ever been convicted of violating Prohibition laws. Dockets from 1921 established that she had been brought up on charges that year and been fined for illegal possession of alcohol. A 1922 alleged violation was also found, but the department had not been able to make a case against her for that one.

The assistant attorney general, Isador Topper, argued that Ardell's permit should be revoked because she failed to come clean about her previous conviction on her liquor permit application.

Ardell's attorney, State Representative Bernard J. McCluskey, argued that the club had no complaints. "It is a private club, so private in fact, that the state liquor inspectors were unable to obtain admittance without membership cards," McCluskey said. "But the department went to all the trouble and expense to bring two inspectors here from Columbus who searched through court records to find a thirteen-year-old liquor charge."

Hughes questioned Ardell about the management structure of the Hollywood Royal Club. She told him it had three hundred members, each paying one dollar a year for dues, and that while there were no set social functions, members amused themselves by having cocktails and talking business. Two of her nephews, a gas station attendant and a cab driver, were on the board, but she made the major decisions. When Hughes asked to see the membership list, Ardell refused. She told him she would produce it for his eyes only, but she would not allow it to be made public.

Ardell lost that round with Hughes and Topper but appealed. Finally, in early 1935, the State Liquor Board yanked her permit for good on the grounds of her 1921 Prohibition law violation and that the Hollywood Royal Club did not fall under the law's definition of a private club.

Ardell had been lucky so far as criminal entanglements were concerned. That was to change with a surprise raid on the Hollywood Royal Club on the night of September 26, 1936. Between eight and nine o'clock on that Saturday night, about twenty G-men surrounded her luxurious vice resort and crashed the party.

This time she was charged with violations of the Mann Act, sometimes called the White Slave Traffic Act of 1910. The law prohibited the transportation of women across state lines for immoral purposes. Ardell had never faced federal charges before. Authorities claimed that on September 8 she was responsible for bringing Gertrude "Gypsy" Currier from Dallas, Texas, and on September 17, Gladys Carter and Helen Claude from St. Louis and Joplin, Missouri, respectively, to Ohio for immoral purposes.

During a search of her home, authorities found and seized her "blue book," said to contain the names of some of the most prominent men in the city. Eliot Ness was the city's public safety director, and he was especially interested in this book. Feds believed it contained the names of at least sixteen police officers who were allegedly guilty of graft.

Along with the book, agents found business cards of clients. Apparently the girls would select the business card of the client they were going to visit. They would then present the card to the client as identification.

United States District Attorney Emerich B. Freed wanted a $25,000 bond on Ardell, but the United States commissioner, B.D. Nicola, thought that was excessive and in violation of her constitutional rights. He fixed her bond at $10,000, which was furnished by U.S. Fidelity and Guaranty Company.

Bond for Gypsy, Gladys and Helen was set at $5,000 each. None of them could come up with the money, so Nicola ordered them to be held incommunicado, except for their attorneys.

The grand jury handed down an indictment of two counts of trafficking on each of the three young women for a total of six counts. The first count charged that Ardell induced the young women into coming to Cleveland for immoral purposes, and the second count charged that she caused them to engage in immoral acts.

Ardell Quinn

These were the most serious charges Ardell had faced. If convicted on all counts, she was looking at a maximum sentence of fifteen years and a $15,000 fine.

Ardell waved a jury trial. Dressed in a muskrat coat and fashionable cloche hat, she appeared before Federal Judge Paul Jones. Prosecutors supplied telephone and telegraph records to show how the feds made the connection between Ardell and the three women and how she seduced them to cross state lines for the intention of prostitution.

It came out later that

Ardell Quinn was found guilty of the Mann Act in 1937. *The Cleveland Press Collection, courtesy of CSU Michael Schwartz Library, Special Collections.*

Ardell's arrest was incidental to what the G-men were really after. They had tapped her telephone lines in hopes of catching bigger fish—namely Public Enemy Number One Alvin Karpis. Ness narrowly missed capturing Karpis when he slid out the back door during a raid on the Harvard Club. Authorities had heard from a credible source that Karpis had been tipped off by a couple of the girls working at the Hollywood Royal Club.

The star witnesses were Gypsy Currier and Helen Claude. Each of the women testified that she paid Ardell $15.00 a week board plus $2.50 for laundry and split her "professional" fees of no less than $10.00 a trick fifty-fifty. The going rate at the time for most prostitutes was $2.00. If the girls went to another city to visit clients, they could charge as much as $100.00 plus train fare.

Both Gypsy and Helen were hesitant to testify against Ardell. Gypsy, described as attractive and soft voiced, told the court that she was twenty-six

and had been a prostitute for the last four years. She had been in Ardell's employ for five months when she went back to Dallas to see a married man she was "very keen on." When it was time for her to come back to Cleveland, she did not want him to know what she was doing, so she wrote Ardell and asked to have a telegram sent saying she should return to her job immediately. Ardell's nephew and an employee from the East Eighty-fourth Street house testified that they had to read the letter to Ardell because she did not read very well.

Red-haired Gladys Carter confessed that she had been arrested in the April 1932 raid. She was nineteen at the time and had given her name as Catherine Schultz.

Helen was not as forthcoming about her September 17 phone conversation with Ardell. The assistant district attorney refreshed her memory by reading from the taped transcript, which revealed that Ardell's telephone had been tapped. Helen was in St. Louis at the time, and she had called collect from a pay phone. During the conversation, she mentioned a letter she had received from Ardell. "How do you think I'll go up to Cleveland," the assistant district attorney read from the taped conversation. "I'd leave tomorrow, but I don't have any money." Ardell then had asked Helen if she knew any other girls who might want to come to Cleveland to work.

Judge Jones found Ardell guilty of four out of the six counts of violating the Mann Act against interstate procuring of prostitutes. He felt it significant that one woman came to Cleveland after talking to Ardell.

Ardell's facial muscles twitched as she stood listening to the sentence. Jones gave her a year and a day on each of the four counts to run concurrently. He added $500 in fines, which he thought she should fork over to reimburse the expenses in prosecuting the case.

"Judge, I just want to say, I didn't bring any of those girls here."

"I'm not going to discuss points of law with you," Jones said. "I am not concerned about correcting your morals."

Her attorneys immediately filed an appeal and secured a $5,000 bond. Eliot Ness finally got his hands on the blue book and began investigating four ranking Cleveland police officers. He was mainly looking for graft. Apparently the officers' names were noted several times in Ardell's records. They were also heard on Ardell's tapped telephone lines while the FBI was trying to track Alvin Karpis.

There were between sixteen and twenty names of police officers in the blue book. Ness suspended the four high-ranking officers, but nothing was ever made public.

The book never saw the light of day, to the relief of those in it. It was not introduced in court because Ardell's lawyers conceded that she ran a house of prostitution.

Ardell adamantly denied that the book was a list of patrons and business associates. "The federal agents missed the real list," she claimed. "If they had gotten that, they would have had something." She contended that the blue book was only a list of friends, and the police officers on the list were friends of hers. She continually denied that she ever paid for police protection. She quickly learned that many names on that list were not true friends. "A woman struggling alone hasn't a chance in this world," she told a *Plain Dealer* reporter.

She had IOUs from customers who had run up bills, but when she tried to call to collect on them she could not get past their secretaries. Without money from the club coming in, she was broke and was forced to sell the paintings off the walls, the rugs off the floors and Queen Anne furniture from the once sumptuously appointed rooms to pay her legal bills. To make ends meet, she rented out the rooms on the second and third floors of the huge house.

If she lost the appeal, she could not afford to carry it any further. While she awaited a decision on her appeal, she helped a friend open the Tea Kettle Inn in North Olmsted. It was a restaurant on the first floor where Ardell waitressed. Reportedly, her friend, a divorcée, lived upstairs.

Ardell's appeal was denied by the United States Circuit Court of Appeals on November 3, 1937. It was final; the once notorious Cleveland madam was going to jail to serve out her sentence.

She took ill with a bronchial infection and was hospitalized. When her health stabilized, she was allowed to go home to convalesce for a few weeks. Finally, on December 20, federal agents escorted her to the federal reformatory in Plymouth, Michigan, where she served out her sentence.

Little is known of what happened to her after prison. A death certificate shows that Ardell died in Parma, Ohio, in 1984. The age on the certificate was eighty-five, but Social Security records as well as census records showed that she was born in 1894, which would have made her ninety-five. The record gives her marital status as never married. Her birth country was listed as "remainder of the world."

Chapter 3

Rose Tauro

A Bullet for a Blade in Niles

Italian immigrant Rose Tauro was determined to get revenge on that October day in 1899. She left her Mason Street home in Niles with her five-month-old baby on her hip and a .32-caliber pistol concealed in her skirts. Her mission was to put a bullet in Frank Augusta's brain. She was convinced he was the man who had murdered her husband, Dominick, and gotten away with it.

Dominick Tauro had felt the cold, steel blade of a knife during a fight among bitter factions of a reported fifty "Italians" and "Greek Italians" near the Erie Round House in East Niles. The men were enemies because they were from different provinces in Italy. The fight started on Sunday afternoon, June 18, over insults to their respective homes. Tauro belonged to the former class of "Italians" from the Seven Hills of Rome, while Augusta was one of the "Greek Italians."

Tauro was cut just above the appendix. The night of the fight, he regained consciousness long enough to tell Mayor Holloway that it was a "Greek Italian," Frank Augusta, who plunged the knife into his side, partially severing his spinal cord.

Holloway ordered Augusta arrested, along with five other men who were involved in the fight. To save his own skin, Augusta denied the charge and fingered Frank Dunaldo. Newspapers of the day were not clear on names, but

Rose Tauro

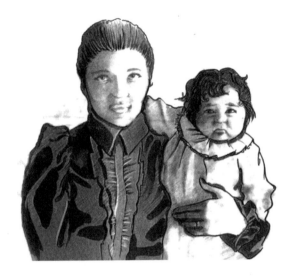

While holding her baby, Italian immigrant Rose Tauro took revenge and shot Frank Augusta. *Illustration by Justin Campbell.*

the other five men also denied having anything to do with the knifing. Each of them accused someone else, making it hard for authorities to sort out the facts.

A Youngstown attorney known only as Serfino charged Mike Salino with holding Tauro while Augusta stabbed him. Tony Ruse and Gethna Javante were among the men bound over to common pleas court to answer charges of assault and battery. Salino, however, was charged with intent to maliciously kill Tauro.

By the time the second preliminary hearing rolled around, eight Italians who were involved in the fight were being held for "the murder of one of their countrymen," according to the *Western Reserve Chronicle.* The hearing was held in Judge Pickering's court to sift through the facts and sort out exactly what had happened. The prosecutor questioned thirty people but could not determine who the cutter was. None of the witnesses would admit to seeing anything, even though they were in the middle of the melee.

Augusta, Ruse and Javante were released on $50 bail. Bond was set for $500 on the other five men. None of them could make the bail, so they were carted off to the county jail. The *Western Reserve Chronicle* reported that prosecuting the case would be costly to Trumbull County, and in the end a conviction was doubtful even though Tauro's relatives and friends were pushing for a trial.

In August, a number of Italians who were suspected of participating in the street brawl that killed Dominick Tauro left Niles and returned to

Italy. A *Chronicle* correspondent believed they left because they were afraid of being jailed. The reporter further predicted that it would be hard to get a conviction on Augusta. Although Tauro named Frank Augusta as his assailant in his dying statement to Mayor Holloway, it was not committed to paper, so it might not stand up in court.

Talk among Tauro's friends and many family members was that they would hire a celebrated Philadelphia lawyer to prosecute Augusta if he was indicted by the grand jury. But in September, the grand jury failed to return a true bill against Augusta. The evidence was too conflicting. The dismissal of charges fueled the widow Rose Tauro's thirst for revenge. Days before she set out on what she saw as her duty, she visited her uncle, Frank Fusco. Could this be where she got the weapon?

On the Sunday afternoon that she looked for Augusta, she had no trouble finding him. He was deep in conversation with some of his friends in front of a tenement house where he most likely lived. Rose drew the gun from her skirts and calmly took aim at his head. Apparently Augusta had not noticed her. At the warning of one of his friends, he turned to face the barrel of her gun. "You killed my husband," she said, "and I will kill you." With a steady hand and a cool head, she pulled the trigger.

The bullet entered Frank Augusta's temple, and he died an hour later, leaving a wife and two children.

Rose gave herself up and was taken to the Warren lockup. She admitted shooting Augusta and was shown to the ladies' apartment in the jail, her baby in her arms. The guards reported hearing her sing in a rich soprano voice for more than a half hour after that. Apparently she was contented with her actions and had no worries for her own future. She said her Dominick had been a good man and Augusta was not. She told her jailers she had sworn to avenge her husband.

Rose's friends told authorities that she had threatened to kill Augusta if the grand jury did not indict him. An unnamed friend said Rose harbored a grudge against all the "Greek Italians" who were involved in her husband's death and that she would extract her revenge on them.

The public was in sympathy with Rose, a "bright appearing, rather good-looking young Italian woman," the papers said. Many people felt she was justified in killing the man who had knifed her husband.

Rose spent three days in jail before the preliminary hearing. Mayor Holloway came to Warren to hold the hearing, where he charged her with

second-degree murder. Although she initially admitted to pulling the trigger, she pleaded not guilty at the hearing. Holloway placed her under $1,000 bond because of the baby and requested her to face a grand jury at the January term of court.

The next morning her uncle, Frank Fusco, a Nile grocer, furnished the bond. That afternoon, she took the Erie train home to Niles, where she was met by an energetic crowd. They shouted their approval of her killing Augusta. She did what the law had failed to do.

After her release, Rose was walking down Depot Street one day when twenty angry "Greek Italians" bent on revenge for Augusta surrounded

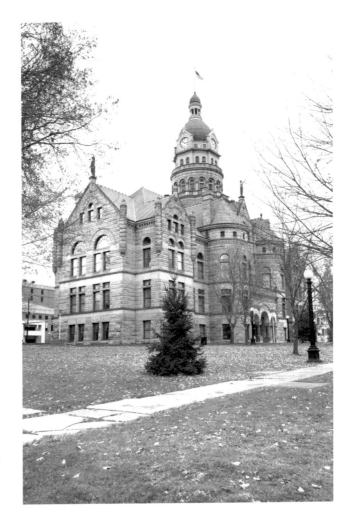

Built in 1895, the Trumbull County Courthouse is one of the oldest judicial facilities in Ohio. *Photo by Jane Ann Turzillo.*

her. Fearing for her life, she ran for Good Samaritan Patsy Jones's house and was taken in until Mayor Holloway and police arrived to disperse the crowd. Before Augusta's friends left, they swore to kill her. The *Western Reserve Democrat* wrote, "The vendetta is on and there is no telling where it will stop."

A week before the trial, Rose went to Warren and asked to plead to manslaughter. The court allowed the plea.

On March 1, 1900, the morning Rose's trial was to start, she failed to appear in court. Sheriff Caldwell called out her name three times, as required, but she did not come forward. Then he called Frank Fusco three times to appear before the court and bring the body of Rose Tauro with him, but he, too, was absent. Fusco's $1,000 bond was formally declared forfeited.

Authorities had a suspicion that Rose might skip out on her bail right after the shooting, but when she stayed around as long as she did, it was assumed she would appear for her court date. A rumor in the Italian community had it that she took her baby and escaped to Brazil. Acting on a tip from relatives, who said she either went to South America or back to Italy, authorities wired New York seaports to be on the lookout for her. Her uncle was very anxious to have her apprehended. Even though they were blood relatives, he wanted his money back.

In June, the *Warren Daily Tribune* carried a story about Rose that said she had killed her mother-in-law in Tursi, Italy, by pushing her over a stone terrace during a quarrel. It was found out later that her mother-in-law survived the "fall."

After that, Frank Fusco petitioned the authorities to release him from the $1,000 bond, and a number of Niles leading citizens were trying to help him. One seven-line paragraph in the December 22, 1900, *Tribune* was the last article about the murder in any of the papers. It reported that Rose had returned from Italy and her uncle was seeking her arrest. The story went cold from there, and no one knows whether Rose faced up to her crime or whether her uncle ever got his money back.

Chapter 4
Marguerite Carlile
Kent Widow of Ex-Sheriff Charged in His Murder

Who shot and killed former Portage County Sheriff Arthur C. Carlile in his bed at 3:15 on Wednesday morning, April 5, 1922? At the time, authorities were certain the evidence pointed to his wife, Marguerite, as the responsible party. To this day, no one knows for sure.

Marguerite was asleep in the bed beside her husband but claimed not to hear the shot fired into Art's head. Instead, she professed to be startled from sleep by a flash. As she opened her eyes, she saw a dark hand stretch across the bed. A shadowy figure snatched her husband's trousers from the footboard. Her screams sent the intruder bolting from the room.

As he dashed out through the dining room, she thought she heard him growl something about "get." Whether it was, "I'll get you," she was unsure. For some reason, he left her unharmed. She ran to the front door to look out the glass and saw a man fleeing west on Oak Street beside their Kent home.

Art and Marguerite's bedroom was on the first floor near the center of their rented house at 815 South Water Street. The bed was situated so that he slept against the wall and she slept on the outside.

The Carliles' three children had been asleep in the rooms on the second floor. One of them, the youngest, awoke screaming when he heard the shot.

Marguerite ran to the telephone to call Dr. W.B. Andrews but had

problems getting through central. After several tries, she was able to speak to him. He came to the house right away. Marguerite told him she could hear the blood dripping from Art's head onto the floor, and she begged him to help her husband. Andrews noted that the skin around the wound on the ex-sheriff's head was burned, indicating he had been shot at close range. Although Art lived approximately forty-five minutes after the shooting, he never regained consciousness.

Close friends and neighbors Edward and Rose O'Bierne got to the house immediately after Andrews. The Carliles had spent the previous evening at the O'Bierne home. Edward carried a shotgun. He and his wife found the back door open and the key to the house lying on the kitchen floor. Art's trousers, minus any money, had been flung out on the porch.

Kent Police Officers Traherne and Montgomery arrived next. On their way into the house, they found a bloody handkerchief. Art's penknife was also found lying in the yard. It was a keepsake with pictures of his children on it.

"I screamed and jumped out of bed," Marguerite told them, wringing her hands. "I could hear the blood gurgling."

Officers Traherne and Montgomery were soon joined by Sheriff J.W. Steven. Testing the burglary theory, he asked her about her husband's trousers. Marguerite said he always hung them in the wardrobe when he undressed for bed. "Evidently the man had taken them out of the closet and placed them on the foot of the bed," she said. She told them there was about fifty-four dollars in the pockets. She was sure of the amount, she said, and recalled telling Art she would not need much money this week. Instead of going into town for groceries as she usually did, she was going to a funeral in Akron.

Marguerite told the sheriff that she and her husband had been at the O'Biernes' home during the evening. When they returned home, they saw two unfamiliar men loitering at the corner of Oak and Water Streets. She remembered another evening when her husband stepped out onto the porch before retiring and noticed a suspicious man in the yard. The stranger claimed to be looking for a particular address. Art was apparently leery and ordered the man to leave.

Could it be revenge? Arthur Carlile had lived his entire life in Kent. In 1912, he was elected sheriff of Portage County and served a two-year term. Two of Art's brothers, Jay and Lou, said the only enemies the ex-sheriff might have had would be the Swigert brothers, whom Art arrested for

stealing chickens. They were sentenced to the penitentiary but could easily be out by now.

According to another brother, Derwin, a Barberton resident, Art did have threats during his tenure as sheriff. He had troubles with one or two criminals whom he jailed, and they had made menacing remarks directed at him. One went so far as to say he would "get" the sheriff. Evidently, Art had taken the threat seriously because he talked about it several times.

Later in the day, Coroner W.J. Thomas examined Carlile's head and found that the bullet had gone straight through. The .32-caliber piece of lead was retrieved from Art's pillow. Next, Thomas wanted to see the mattress but was told that it had been burned. It was soaked with blood, so for some unknown reason Officer Montgomery directed the undertaker, Samuel Bissler, and O'Bierne to destroy it. There is no telling whether the burning of the mattress hampered the investigation.

Sheriff Stevens told reporters for the *Ravenna Republic* that it was too early in the investigation to have a theory. "We have nothing tangible to work on as yet," he said. "We have not discarded the theory of burglary or advanced any other."

Stevens knew Carlile owned a gun, and he wanted to see it. It was a pearl-handled revolver that his brother-in-law, William Harnett, had given him. Carlile carried it while he was sheriff. The problem was, no one could find it.

Deputies asked Marguerite about the gun. She told them Art always kept it in the lower dresser drawer, but recently he took it to his locker where he worked at the Erie yards. Having a gun in the house made him nervous because of the children. In January, he brought it home and cleaned it because he was going to sell it, she said. Deputies made a thorough search of the house and his locker at the Erie Roundhouse, but it was nowhere to be found.

The coroner held an inquest a few days later, and Marguerite was called to testify. She spent several hours on the stand answering questions from Prosecutor V.W. Filiatrault. Her answers seemed to be simple and straightforward. He asked her why she thought the burglar took the trousers out of the closet, rifled the pockets, placed them on the end of the bed and then grabbed them and took them with him, only to drop them on the porch. Marguerite's answer was that she was not certain the trousers were in the wardrobe to begin with, although her husband usually did hang them in the closet.

The prosecutor then asked her why she thought the intruder had not shot her. Perhaps Art moved in his sleep, she said, startling the man, making him think her husband was going to rise up and attack him. It was the only answer she could offer. She repeated how she awoke from a flash and sat up in bed screaming.

Filiatrault grilled her on her marriage. She met Arthur C. Carlile when she was seventeen and working in a restaurant, she told him. They had been married for seventeen years. It was a good marriage, she insisted, free of serious differences. She said he had gotten angry at her only once when he found out she lied about paying a $31 grocery bill. He hated owing money, she told the prosecutor, and so she turned over some stock to pay the grocer. Lou Carlile remembered a larger, $125 bill to another grocer that his brother did not know about.

Marguerite Harnett's formative years were troubled. She was born in Pittsburgh, Kentucky. When she was nine, her parents separated, and she lived alternately with each parent, but her father, a coal miner, was better able to support her. He was a strict Roman Catholic and a member of the Grand Army of the Republic. During one three-year stretch, her family moved around in the mining district, but she received some school during this period.

Tragedy followed the Harnett family from place to place. One of Marguerite's brothers was murdered; another was shot by police; one was killed in an accident; and still another was convicted of manslaughter.

At a young age, Marguerite went to live in Dayton with acquaintances of her father. From that time, she became self-supporting. Her father often gave her money, sometimes as much as $200 at a time. He died in Tennessee in a soldiers' home. Her mother still lived somewhere in the South. Marguerite's father called his ex-wife a devil whom no one could live with. Her mother visited her in Kent a couple of times. On one of those visits, she brought another daughter to the house who was supposed to be "out of her head."

Lou Carlile told the prosecutor of a time when Marguerite drank. He detailed how her older daughter came home from school one day and found Marguerite passed out on the bed. The girl was frightened when she could not wake her. When Art found out about it, he threatened to take the children and leave if it ever happened again. Art's mother, Abbie, gave Marguerite a talking to about the episode, and it never did happen again.

Marguerite defended herself by saying she had drunk some wine and it affected her. She proclaimed that was the only time she had ever become

intoxicated. She admitted that she and her husband did drink homemade wine and beer, but they never drank to excess.

Money was no issue in the Carlile household. Art always had a good job and made anywhere from $100 to $300 a month. Except for the two-year period when he was sheriff, he worked as a machinist and pipe fitter, first in his brother's plumbing business, then for the Goodyear Company and later for the Erie Railroad. He turned his pay over to Marguerite, who managed the household.

The question of the missing gun kept coming up. Police had found a locked box in a closet by the dining room. Marguerite gave Detective Shrewder the key to open it. Inside he found some insurance papers and a box of five .32-caliber cartridges.

While the coroner's inquest was in session, Shrewder went to search the house again. This time, he found Art Carlile's pearl-handled revolver shoved between two mattresses in an upstairs closet. Shrewder and Officer Traherne had searched the same closet on the day of the murder, and the gun had not been there. The detective examined the gun and said the chamber was empty and it had been cleaned. William Harnett identified it as the gun he had given Art years before.

The fifty-four dollars Marguerite claimed was in Art's trouser pockets allegedly grabbed by the intruder was found in the house. Later it was learned that the amount was only three dollars.

Marguerite and the Carlile brothers were not happy with the investigation thus far, so they hired the Kane Detective Agency from Youngstown to work on the case. The private sleuths soon made a statement that they had uncovered some clues, but they would not divulge what they were. John Kane did say he thought the motive was revenge and not burglary. He requested records of all the men sent to the penitentiary during Carlile's term as sheriff. Kane also wanted a look at the list of lunatics the former sheriff may have taken to the Massillon State Hospital.

Police knocked on doors, but not even the nearest neighbor, whose window was only ten feet from the Carlile house, had heard anything the morning of the murder. None of the neighbors or friends ever knew Art and Marguerite to have any troubles.

Filiatrault was certain it was a premeditated murder. None of the police believed Marguerite's version of the crime either. She knew the police were

beginning to target her as the suspect. "They are blaming this on me," she cried to Officer Montgomery, who was one of the first policemen at the scene and had directed the mattress to be destroyed.

Filiatrault and police went to Marguerite's house to question her, trying for a third time to catch inconsistencies in her story. She held to the same sequence of events as she told the morning of the murder and then again at the inquest. After about an hour, the prosecutor and police were frustrated at not being able to shake her story. They retreated to the porch, where they talked over the evidence, and finally left.

Kane was working on the theory that the shooter left on a train. Two Erie freight trains passed within an hour of the murder. The *Ravenna Republican* reported that the man who ran from the Carlile house was tracked to the rail yards, where he was seen. Both Kane and Marguerite's attorney, Blake Cook, were anxious to talk with the trainmen who were there at the time. Apparently nothing ever came from that lead.

The coroner's inquest was abruptly suspended, but Filiatrault was dogged. The Portage County sheriff's office and Kent police clammed up on the case. Then, on April 19, the prosecutor announced that the Pinkerton detectives from the Cleveland office had joined the investigation. "There are some very interesting developments in the case as a result of the detectives' investigation which we are not yet ready to announce," he said.

Authorities were becoming increasingly more suspicious of Marguerite. They dismissed the burglary theory because the money from the trousers pocket was accounted for.

After a month of keeping the investigation confidential, Filiatrault felt he had enough evidence to arrest Marguerite and lock her up in the Portage County jail.

On Saturday, May 21, at about 8:30 in the evening, Sheriff Stevens and his wife appeared on Marguerite's South Water Street doorstep. She and her youngest child were alone. "Mrs. Carlile, I have bad news for you," Stevens said. "I have a warrant for you for shooting Art, and I will have to take you to Ravenna."

Stevens said she showed little emotion but asked to take care of some baking she had been doing in the kitchen. She called her attorney and then placed a call to her mother-in-law and told her "the worst has come."

Stevens recalled that as she made arrangements with Abbie Carlile for the children to be taken care of, her voice faltered. As she hung up the phone, she asked if there was new evidence. The sheriff replied he did not know. She retorted that they could have at least waited until Monday.

The elder Mrs. Carlile greeted her daughter-in-law at the door with an embrace. Both women began to cry. "May God protect you," the older woman said. The child burst into tears when he realized his mother was going to be taken away. He threw his arms around her and refused to let go. Stevens tried to quiet the child, but the little boy only got hysterical.

At Ravenna, Marguerite was subject to relentless grilling throughout the night, ending at 5:30 the next afternoon. She remained stoic throughout the ordeal, never contradicting her original story. Although she must have been exhausted, she gave the outward appearance of being resigned.

Her attorney, Blake Cook, met with her at the jail Sunday morning. He told the *Ravenna Republican*, "This woman is absolutely innocent. Her arrest, tearing her away from her family is an unfortunate thing, but then perhaps, it is for the best, as it will result in her being entirely cleared." He told reporters that they were diligently working on apprehending the real murderer. He was the only visitor she was allowed. Authorities would not release her on bond due to the charge of first-degree murder.

At the preliminary hearing, Justice H.W. Campbell heard Marguerite's plea of not guilty in a clear steady voice. Wearing a black frock, black hat and dark blue coat, Margaret sat primly beside her attorney, watching as police officers and her neighbors and friends gave testimony.

Questioning of the Carliles' closest neighbor brought out a suspicious comment that Marguerite had once made: "If Art talked to me like your husband does to you, I'd kill him, but I've got a good man." The neighbor said she had never heard any arguments coming from the Carlile home.

Marguerite looked wan and somewhat haggard but remained emotionless except for a few tears near the end of the hearing.

Campbell decided there was enough evidence to bind her over to the grand jury but thought the evidence was not as weighty as usual in a first-degree murder case. He decided that she should be released on $10,000 bond.

Two Kent businessmen signed for her bond. After six days in a jail where she had once been the matron, Margaret was free to go home.

Her attorney was not surprised at Campbell's decision on bond. He told the newspaper, "We are continuing our search for the murderer. We intend to track down the person who killed Arthur Carlile. We will find him if it is humanly possible."

Marguerite remained free and lived with her in-laws until the grand jury returned a true bill against her on November 27. She was rearrested and brought back to the Portage County jail, where she would remain until after the first of the year.

On January 10, in a special night session of common pleas court, new Portage County Prosecutor A.L. Heisler entered a *nolle prosequi*, an intention not to prosecute Marguerite Carlile. Common Pleas Judge A.S. Cole agreed with the decision.

Heisler cast a critical eye at the evidence in the case. It looked to him like it was all circumstantial and not sufficient at the time to secure a conviction. It would thus be a waste of public money. A second reason was that if Marguerite was acquitted, she could not be tried again even if she were to admit to the murder.

Marguerite agreed to stay in Portage County until the next June. She and Blake Cook said they would cooperate fully with authorities. It was their intention to hunt down the murderer and bring him to justice, they said.

There was never a trial, and no one else was ever arrested for Art Carlile's murder. He is buried in the family plot at Standing Rock Cemetery. His wife, Marguerite, faded into obscurity.

Chapter 5

Ellen Athey

Jealousy Leads to Axe Murder in New Philadelphia

"The blood of Mary E. Seneff cries aloud against the perpetrators of the crime." So the *Ohio Democrat* of June 24, 1880, described the room where the hired girl was hacked to death with an axe by her employer, Ellen Athey.

That Friday evening of May 28 had begun on a pleasant note. Husband Henry Athey had taken the spring wagon to go work at the salt wells, so Mary and Ellen, who seemed to be good friends, took Ellen's two little ones and walked about forty steps across the yard to the Crites house. David and Lydia Crites were Ellen's parents. Ellen's brothers, Alexander, Daniel and Frank, were also there. The family compound was three miles southwest of New Philadelphia.

A good meal, convivial conversation and neighborhood gossip soon gave way to song. Music filled the house as seventeen-year-old Frank played the organ and Daniel and Mary harmonized their voices. Ellen joined in by singing to her baby daughter.

About 10:00 p.m., Mary and Ellen headed back to the Atheys' log house. The children were put down for the night, and the two women readied themselves for bed. As they disrobed, Ellen's demeanor changed. She accused Mary of trying to steal her husband. Ellen lavished love on Henry and was insanely jealous.

At that moment, Ellen unleashed stored-up rage. She charged Mary with coming over to her house during April and tapping on her window at night. Mary had been working for Lydia Crites at that time. Ellen insisted it was a signal to Henry to go outside and join Mary.

Mary Seneff, clad in only her chemise and drawers, disavowed the charges. She told Ellen that she had seldom spoken to Henry Athey. Ellen turned a deaf ear and exploded. She flew into the kitchen. When she returned to the bedroom, her fingers were locked around the handle of her husband's axe. In a murderous frenzy, she chopped the life out of Mary.

Twenty-seven-year-old Ellen had always had an uncontrollable temper. Jealousy often brought out malice and warped her reason. Since childhood, she could fly into a rage upon the least provocation. Three years before the murder, Ellen had attacked another woman. David Crites kept his daughter out of the penitentiary in that incident with considerable expense and trouble.

In addition to three brothers, Ellen had two sisters. One—Mary Crites— was Henry Athey's first wife. When Mary became ill, Ellen moved into the Athey house to care for her sister. In actuality, her reasons may have been more sinister. She set about winning the affections of her sister's husband and perhaps hastening her sister's demise. It was not too long after Mary's funeral that Ellen Crites became Ellen Athey.

The Atheys had been married for five years. Henry had two children, ten and seven, by his first wife and a ten-month-old daughter with Ellen. Ellen had gotten pregnant a second time but suffered a miscarriage in the latter part of April 1880.

Lydia Crites said that her daughter had nearly died as a result of the miscarriage. "She was very poorly. She was in a fainting condition when I got there." Ellen lost a great deal of blood and remained in bed for nearly two weeks.

"Ellen's mental and physical condition after her sick spell was not good," her mother said. "She did not attend her work as she had been in the habit of doing, and that is why I noticed that her mind was not as good as usual. Before her sick spell she done her work as good as any woman. She wasted or flooded a good deal."

The doctor attending Ellen agreed that she was weak from excessive hemorrhaging. Although he gave her medication, the hemorrhaging continued off and on. He told Lydia that the loss of blood could be

debilitating both in body and mind. Even before regaining her strength, Ellen set off one day on foot to find Mary Seneff.

Mary Elizabeth Seneff was well liked by her acquaintances. She was modest and good looking, short and weighed about 150 pounds. Although Mary was born in Ohio, her father moved the Seneff family from York Township to Clarks Prairie in Davis County, Indiana, when she was three years old. Mary came back to Ohio to live with her sister, Sarah, and brother-in-law, John Resler. During Ellen's murder trial, Sarah said that Mary was in the habit of "working out," meaning that she looked for employment outside the home.

Mary's and Ellen's paths first crossed when the industrious eighteen-year-old began working

Ellen Athey (pictured) murdered Mary Seneff out of jealousy. *Courtesy Dover Historical Society.*

at the David Crites farm the first of March 1880, helping Lydia with housework. David was Mary's cousin, so she lived in the Crites home for five or six weeks.

Three days before the murder, Ellen sought Mary out and engaged her to come work for her. She explained about her miscarriage, saying she was still weak and needed help with house cleaning. She promised to pay Mary, and pay her well.

The first day, Mary helped clean up after Ellen's miscarriage and carried out the bloody bed ticks. A friend, Mary Klar, also came to help. Together they whitewashed the one room upstairs and scrubbed the floors. On the second day, they papered the bedroom and put down carpet, ironed the curtains and put up blinds. Thursday, the third day, Mary and Ellen cleaned up the kitchen, papered it and scrubbed the floor. On Friday, Ellen baked

bread, pies and cake. She washed the doors, blackened the stove and papered the cupboard and closet.

It looked to Lydia like Ellen and Mary had become close friends, but she did not know what was really in her daughter's heart.

Sarah Resler was concerned when she had not seen or heard from Mary in a week or so. She became alarmed when she received a strange letter dated June 4, purporting to be from Mary. It stated that she was going home to see their mother in Indiana. The letter was not in Mary's handwriting and her name was spelled wrong— Marry Senneffet. Sarah and John knew Mary had been working at the Atheys' the last few days of May. When the Reslers went to see the Criteses and Atheys, they were told that Mary had gotten up at four o'clock Saturday morning, May 29, and gone to Dover on foot looking for work. But Sarah and John were suspicious and went to the authorities.

Mary's body was found early on the morning of June 15 by John Kraus on his way to work at the coal bank. He saw something large floating in Sugar Creek a half mile south of Dover, just below the iron bridge that crosses Shanesville Road. At first it looked like a bundle of hay, but then he saw something like an old quilt sticking out of it. He tried to reach it with a stick, but it was too far from the bridge and shore. He continued on to work and related his finding to the other workers.

About a half hour later, he and William Deiser returned with a long iron hook. They hooked the bundle and floated it to shore. As they tore it open, they saw what looked like the forehead of a person. A crowd had gathered by then. Four men lifted the body to the top of the riverbank using strips of muslin as slings under the bundle. The partially decomposed corpse was wrapped and tied in a sheet and then placed in an old quilt along with five or six bricks. The quilt was sewn along one end and up the side. The open end was tied with a stout string. Curiously, the bundle also contained walnut shells, coal ashes and cabbage stocks. Three calico dress skirts were stuffed inside the bundle at the head of the body.

A drizzling rain set in on the crowd that watched Drs. Selden and Brannon examine the body on the riverbank. Mary was clad only in her chemise and drawers. Her body was in an advanced state of decomposition, with skin having sloughed off her legs and one arm, her nose and eyes missing and her teeth having fallen out. It was plain from the contents of the bundle that

about it, so Ellen did. When she looked out, she saw Mary stepping down off the porch.

On the night of the murder, Mary and Ellen went to bed. Mary fell asleep, but Ellen could not sleep, she said. Something told her that Mary and her husband were going away the next morning. She made up her mind they would never get away with it. She thought about it until nearly midnight, and then she got up and got the axe. When she got near the bed, her heart nearly failed, but she thought if Mary and Henry went away together, she would never see him again.

Mary was always talking about going home, Ellen told Bet. The night of the murder, Henry did not come home from the salt well. Ellen took that to mean that he and Mary were going to run off together the next morning. It was a sad affair, Ellen told Bet.

Ellen went on to describe the blows she delivered to Mary with the axe. Mary cried out, "My God, Ellen, what have I done to you that you are trying to [kill] me?" When the deed was done, Ellen simply sat down at the end of the bed. [B]et asked how she had managed to bury the body. At that, Ellen showed [her a]rm and said, "Oh my God, I am stout."

[She] then told how she had stitched the corpse up in a coverlet and stuffed [clo]thes in with her. She dug the grave herself, dragged the body outside [cove]red it over with about a foot of dirt, and then set about to clean the [up t]he house. She repeated how stout she was.

[Af]ter hearing all the chilling details of the murder, Bet allowed Ellen [the n]ight. Apparently the two slept in the same bed! When Bet opened [in th]e morning, Ellen was resting her head on her elbow looking at [her. Sh]e told Bet to go down to the jail to see about her sick child, fearing [it may]have frozen to death overnight.

[It is uncertain] as to whether Bet or her liveryman alerted the sheriff, but [when Bet r]eturned to her house, Sheriff Lyons was there. One of the [depu]ts said he found Ellen hiding between two mattresses with [a knife in] her. As the sheriff led Ellen away, Bet fixed her veil for her.

[The trial began o]n February 21, 1881, and lasted thirteen days. It took [only 1]2 jurymen out of 133 who had been summoned from [the c]ounty. The courtroom was crowded with women, there [were also] the 500 men who were waiting outside the courtroom. [They came to s]ee the accused and hear the dramatic testimony.

she had been buried somewhere for a period of time before being thrown into the water.

A full autopsy at a doctor's office revealed foul play. Her skull was fractured over the right eye. She had a fractured cheekbone and jaw and at least a dozen cuts and slashes. What looked like defense wounds were apparent on her left arm and hand. There were cuts on her back and hip. One gash on her shoulder severed a small bone in her scapula. The doctor noted a three-inch wound on the right side of her chest under her arm. She suffered still another cut across her cheekbone under her eye.

From the wounds, it looked as if she had been attacked with an edged instrument such as an axe or hatchet, but the doctors believed a blunt instrument had caused the fracture over her eye. That injury alone would have caused death, as would the wound to the right side of her neck. Finally, the doctors found a deep gash under each ear, and they speculated that the murderer had tried to hit the jugular.

They thought she had been dead about two weeks. Her body was decomposing so fast that immediately after the autopsy, she was buried. But by the next day, there was gossip that she was pregnant. At 2:00 p.m., Brannon ordered her body exhumed for further examination. He determined that she was not pregnant, but when he looked more closely at her wounds, he found that the attack was even more violent than he had first thought. He found more fractures to her skull and deep gashes in her flesh. He thought the damage was done with an axe. She was reburied about 5:00 p.m. that day.

That same evening, Mary was exhumed again for positive identification by John Resler. Sarah did not view the body, but she broke down and wept as she identified the chemise as one she had made for her sister a week before her death. Sarah had made the drawers a year before that. Mary's final resting place is in the East Fourth Street Cemetery.

The coverlet had bars and a stripe pattern to it. Mary Klar recognized the quilt right away as one she washed for Ellen. Suspicion mounted toward the Atheys.

About 3:00 a.m. the next morning, the constable and his deputies descended on the Athey house. They took Henry and Ellen Athey and Alex Crites into custody and set about examining an ash heap near the privy and the hog pen. The ash pile had recently been dug up. As they dug around in the pile with a stick, a stench nearly drove them away. One of the men

testified at court that it smelled about the same as the dead body had smelled. The deputies got a shovel and raised the dirt. They found cabbage stock and walnut shells, as well as pieces of brick—all matching the debris on Mary's body. They also found a stocking, pieces of a calico apron saturated in blood and a garter.

Afterward, they took measurements of the makeshift grave. It was five to six feet long, three feet wide and ten inches deep.

They found wet, muddy men's and women's clothing hanging in the kitchen. A muddy spring wagon stood in the barnyard. There was hay in the bed and an axe.

Ellen had told her brother Alex what had happened. He told Henry, and Henry told Ellen's father, David. David demanded that they get rid of the body. Because it smelled so bad, they made Ellen dig it up herself. She sewed it into a quilt, and Henry, Alex and Daniel disposed of it by throwing it in Sugar Creek.

Ellen, Henry and Alex were arrested and jailed without bond. Alex and Henry were charged with complicity.

The house was thoroughly searched later that morning. Mayor William Campbell found a parasol slide and patent shoe buttons in the cook stove. They were warm when taken out and later identified by Mary's sister.

Underneath the new wallpaper were streaks of blood. Ellen had evidently tried to cover up bloodstains by pasting new matching paper over the old stained pieces. When they moved the bed, they discovered blood on the wallpaper at the head of the bed.

The floor looked like it had been scraped and scrubbed, but there were still stains in the wood. They took the washboard off and found it was bloody. They cut the stained pieces out to take with them. When they cut the floorboard out, they found clots of blood as big as plates in the dust under the house.

They found slashes in a clean comforter and bed tick that matched up to hack marks in the wood of the bedrail. Neighbors said they drove past Ellen's house the day after the murder and saw her out in her yard doing a washing in the rain.

The searchers found a book of paper with the name Ellen Crites on it inside a trunk. It was the same kind of paper as the letter written to Mary's sister. The tear marks on one of the pages were compared, and they matched up.

Coal ashes were found in the bed of the spring wagon. A closer look at the axe revealed blood on the handle near the eye of the axe. To establish if it was truly blood on the axe, the constable consulted Drs. John Hill and J.M. Smith. They took samples from the axe, submitted them to ether and put them under a microscope. What they found were crystals indicative of human blood.

After four months in jail, the grand jury refused to indict Henry and Alex, so in November they were set free. Ellen remained in jail and would stand trial alone.

January 1881 was bitter cold. During the day, Ellen was confined to large room with a fireplace on the ground floor of the jail. At night she locked away in one of the iron cells, but on Friday night, January 13, Lyons allowed Ellen and her sick child to stay in the room with the There were locks on both doors to the room.

Sometime after midnight, Ellen used a hot poker to burn Leaving her child behind, she headed up Main Street towa James Kennady, who lived near that corner, was awake sick child when he happened to look out the window. walking up the middle of the street, but he did no watched the woman sit down on the doorstep ac have sat there for ten or fifteen minutes before n

Elizabeth "Bet" Cordery, who by her own a testified at the trial that Ellen had awakened 2:25 a.m. Ellen had a veil covering her fa of clothing, including short clothes, th cloak, a black coat, a hood, a hat, t black alpaca skirt around her shou

Ellen told Bet that she was nc hair shingled and work in the Newark. She wanted Bet to According to Bet, Elle began to tell her stor Seneff. It all came to husband were in t. that if it were not so. C. at the window, and it would .

Ellen Athey

Tuscarawas County Courthouse, where Ellen Athey's trial took place. *Courtesy Tuscarawas County Historical Society.*

Henry Athey and the small child sat next to Ellen throughout the trial. At times during the testimony, she broke down and sobbed. As each piece of evidence was presented, she watched her counsel's every move, desperate for some gleam of hope, but in the end, the evidence was overwhelming.

The jury deliberated for seventeen hours and returned a verdict of guilty of murder in the second degree. The penalty was prison for life.

In pronouncing sentence, the judge said she was about to be separated from her child, husband, mother, father and all the dearest ties of family, and that in the eyes of the law, she was civilly dead.

Ellen was sentenced to hard labor at the Ohio State Penitentiary for the period of her natural life. She also had to pay the costs of the prosecution. Prison records indicate she was transferred to Columbus Hospital for the insane on September 27, 1884. She died there on April 3, 1922.

Jeanette McAdams

Early Serial Killer in Ashtabula?

The grim reaper visited six members of the McAdams family of Ashtabula between 1848 and 1851. The deaths all occurred under mysterious circumstances and centered on one member of the family. Each victim fell ill suddenly and suffered convulsions. According to one source, each of the deaths was followed by the tones of a howling animal outside the house.

Most of what survives of the story comes from two sources: a manuscript written by Rose Gifford in 1915 using information she got from elderly Catherine Rogers Gillette, who was a seamstress in the McAdams household; and an article by T.J. Thomas entitled "The Six White Stones," which appeared in *The World Wide Magazine* in February 1913.

Alexander and Rebecca (Smith) McAdams came from Saratoga, New York. They settled on North Ridge Road in a large house about a mile and a half east of the village. They had six children: Julia, Arthur, Abigail, Walter, Luther and the oldest, Jeanette.

Jeanette was a peculiar girl by all accounts. There was a certain coldness between her and her father that was never explained. Although she was a pretty girl with dark hair and a smooth complexion, it was noted that her eyes were deep set and lacked warmth. She was restless by nature, and she disappeared for long periods.

The first to die was Julia. According to the *Ashtabula Sentinel*, she took ill suddenly on February 27, 1848. Dr. Coleman, who lived down the road, was called, but she was dead before he could do anything for her. An animal howled outside the window that night, sending chills down everyone's spine. Julia was not quite fourteen.

Right after Julia's burial service at Edgewood Cemetery, Jeanette disappeared. No one had an inkling of where she had gone. All that was known came from rumor—that a tramp in men's clothing had been seen in the area. Folks said it looked like Jeanette through the eyes. After some time, though, Jeanette reappeared.

Catherine Gillette remembered being engaged as a seamstress by the McAdams family after Julia's death. As was the custom in those days, she went to live with the family until the clothing for the year was sewn and all the mending was done.

Catherine slept in the same room as Jeanette. One night, the young seamstress could not sleep. Not wanting to wake Jeanette, she lay very still. After a while, she witnessed Jeanette sliding from beneath the covers and going to a trunk across the room. She opened the lid and drew out a suit of men's clothing. Catherine watched through the dark as Jeanette changed into the masculine garb. Then she came toward Catherine. The young seamstress kept her eyes shut as Jeanette stood above her, evidently making sure she was asleep. Satisfied that she was undetected, Jeanette left the bedroom.

A long time passed before Jeanette returned to the room and quietly shed the men's clothing. She placed it all back in the trunk and crawled into bed.

The next morning Alexander McAdams discovered that his pocketbook was missing. Eight-year-old Arthur said that when he got up for a drink in the night, he saw someone in the woodshed. A quick search in the yard turned up the pocketbook, but it was empty. The money was gone, and a man's footprints led away from the spot. Alexander followed them to the roadway where they stopped. There was no police force in the village at the time, so no one instituted an investigation.

A few days later, Alexander received an anonymous letter that seemed to upset him. He apparently did not share it with anyone. To this day, no one knows what it said, but a short time after the letter arrived, some of his cattle died mysteriously.

One evening in January 1850 as the family sat around the fire, twenty-one-year-old Abigail told her mother, Rebecca, that she had seen men's clothing in Jeanette's room. Another version had Abigail announcing that she had seen a man in Jeanette's room. Whichever is true, Jeanette was in earshot and angrily denied it. Fourteen-year-old Walter stuck up for Abigail, saying he had seen a man once. To settle the squabble, Rebecca went to Jeanette's room to see for herself. She looked in the trunk and found the men's clothing. The tales do not elaborate on what Rebecca made of the find.

Late that night, Abigail staggered into her mother's room complaining of sickness. She said she had eaten some candy that Jeanette had given her. Violent convulsions wracked her body, and she fell to the floor dead. Again the animal howled.

Abigail was laid to rest with her sister Julia at Edgewood Cemetery. Jeanette left soon after the funeral and went to Cleveland. She did not come back until sometime in August 1850.

Shortly after her return, Walter fell ill. He had been working with his father hauling wood strips to make barrels when he complained of sickness. Jeanette helped him to his room, but within an hour he crawled downstairs. Dr. Coleman was called, but once again, it was too late. The all-too-familiar howl floated through the windows.

Jeanette disappeared for a third time but returned by September 12. The next evening, twelve-year-old Luther went to bed in fine fiddle. Sadly, he did not awaken the next morning. He was buried next to his sisters and brother. Jeanette prepared a meal for relatives and friends after his service. Everyone who ate the food became sick. As luck would have it, they all recovered. Jeanette disappeared for a year before returning home.

On December 31, 1850, the family was celebrating the coming of the new year, playing games and telling stories, eating apples and drinking cider when little Arthur was stricken. At first, he lost all color in his face, and then he began shaking uncontrollably. Within a short time, he was dead. An animal's howl pierced the night.

There is an account that a young doctor named Hubbard had the water analyzed after Arthur's death but found nothing wrong with it. Some of the relatives and friends wondered if the cooking utensils, which were made of brass and copper, could have caused the deaths. But poison was always the whisper among neighbors.

One of the six McAdams family tombstones at Edgewood Cemetery. *Photo by Marilyn M. Strubbe.*

Mother Rebecca was the next victim. She was suffering with a cold when Jeanette returned from an unexplained absence. The doctor had already made a visit, but Jeanette took it upon herself to nurse her mother with tea and broth. It was not long before the dog howled and Rebecca joined her children in the cemetery. Like always, Jeanette disappeared.

After several months, Jeanette came home and found her father, Alexander, still grieving. He kept to himself much of the time. As he was getting ready

to go into town for supplies one day, Jeanette asked him to post a letter for her. No one knows whether it was curiosity or suspicion that made him open the letter, and time has lost to whom it was addressed. But there in his daughter's own hand were plans for his death. He flew into a rage and immediately returned home to throw her out of the house.

Jeanette was gone for a long time, and there were many theories of what happened to her during those years. Some folks thought she may have joined a band of gypsies. Others heard that she had become a spy for the Confederate army, wearing men's clothing as always.

At the close of the Civil War, a "dirty, old tramp" appeared at the McAdamses' door. Alexander had remarried, and his new wife let the tramp in and fixed "him" a meal. Surely, the hackles rose on the back of Alexander's neck as he watched the tramp eat. When their eyes finally met, he knew it was Jeanette.

He ordered her out of his house and forced her to get onto his wagon. He drove off with her and returned alone that night. Jeanette was never seen nor heard from again.

Chapter 7
Velma West
A Party Girl in Perry

Velma West was a blonde, twenty-one-year-old, mere slip of a girl who loved to have a good time. She was the life of Mabel Young's bridge party in Cleveland on December 6, 1927, laughing, smoking and singing jazz songs as she played cards. No one could tell by her demeanor that before coming to the party she had bludgeoned her husband, Eddie, to death with a claw hammer.

Velma and Eddie had been planning to attend the party together, but earlier in the day he came home from work at his father's nursery with leg pain. After visiting the doctor in Painesville, the Wests returned to their bungalow on Narrows Road in Perry about 6:00 p.m. He was tired and did not want to go out.

Not wanting to miss out on a party, Velma said she would go alone. Eddie was not fond of her "big city" friends, so he got mad and demanded that she stay home. They quarreled, and she threatened to leave him. Finally, she grabbed a claw hammer and smashed him in the head, crushing his skull. She put a pillowcase over his head, bound his arms and legs with cords and then continued to beat him with a table leg.

When she was finished, she threw a blanket over him, shucked off her blood-soaked clothes, threw them in the furnace and washed up. Then she put rouge on her cheeks and lips, slid into fresh party clothes, donned her hat

Velma West bludgeoned her husband to death and then went to play bridge. *The Cleveland Press Collection, courtesy of CSU Michael Schwartz Library, Special Collections.*

and coat and ran out the back door. She climbed into her husband's green 1924 Hupmobile roadster about 6:30 p.m. and took off for the thirty-five-mile trip into Cleveland.

The party lasted well into the night, so the hostess, Mabel Young, suggested Velma spend the night at her Willoughdale Avenue home. On Wednesday morning, Velma ate a big breakfast and about 9:30 a.m. drove to her parents' home on Paige Avenue in East Cleveland. She and her mother, Catherine Van Woert, went shopping, and she bought Eddie a box of handkerchiefs as a Christmas present.

In Perry on Wednesday morning, twenty-six-year-old Thomas Edward West, heir to a nationally known nursery, did not show up for work. His younger brother, James, was worried. It was unlike Eddie to skip work. James went to the little cottage that was on the nursery grounds and found the back door standing open. Inside, he made the gruesome discovery in the bedroom.

At first, Sheriff Edward Rasmussen thought Eddie had been killed about seven or eight o'clock on Wednesday morning. He based this theory on the

Velma West

The bungalow on Narrows Road in Perry where Velma killed her husband, Thomas Edward West. *The Cleveland Press Collection, courtesy of CSU Michael Schwartz Library, Special Collections.*

fact that the body was still warm under the back. He later realized the corpse was still warm because there was a blanket over him and the house was heated.

Velma came under suspicion right away, but her story seemed to check out. She told the sheriff that she and Eddie had planned on going to the bridge party together, but he did not feel well, so he told her to go ahead without him. They went out the back door; he cranked up the "Hup" and kissed her goodbye. That was the last time she saw him alive.

Mabel Young vouched that Velma had spent the night at her house after the party, and deputies verified that she had arrived at her parents' house in East Cleveland between 9:30 and 10:00 a.m. the next morning.

Still, things did not add up for Rasmussen. He made Velma repeat her story over and over as she sat on the sofa in his office. He listened intently without interrupting, looking for an inconsistency. On the last run-through, he thought he found it. The back door of their house had been left standing open. Why had Eddie not closed the door when he went back in the house?

Rasmussen confronted her with it, and Velma's jaw dropped. The look on her face told him she knew it was over. She sunk further into the couch

Velma West with Lake County Sheriff Edward Rasmussen. *The Cleveland Press Collection, courtesy of CSU Michael Schwartz Library, Special Collections.*

and began to spin a story of self-defense.

She said Eddie became infuriated and started calling her friends names when she decided to go to the party on her own. She said he slapped her face and threatened her. He was coming at her. She was so frightened that she grabbed the hammer and struck him in the forehead multiple times, and he went down. Her first thought was to render him helpless, so she bound his hands and feet. He turned over and started kicking, so she threw the blanket over him and hit him with a table leg. She swore he was alive when she left the house.

Rasmussen did not fall for her self-defense story. To him, it was unlikely that the one-hundred-pound Velma could overpower a much bigger, stronger Eddie West.

After examining West's body, the coroner found several skull fractures, any one of which was sufficient to kill him instantly, so he could not have been alive when she left the house.

Velma did not understand what the preliminary hearing was. She hoped her attorneys would get the charges reduced and obtain bond. Instead, the judge bound her over to the grand jury without bail and ordered her incarcerated until the next session in January.

At the thought of going to jail, she collapsed in great sobs and needed to be carried from the courtroom. Her health became an issue after that, so a trained nurse was hired to act as her companion and guard in her cell. The nurse, Cora Nash, remained with Velma throughout the trial. Her mother, Catherine, and father, Burt Van Woert, visited her often and even made sure she had a Christmas tree in her cell.

Young Thomas Edward West's funeral was a quiet, dignified affair held at the home of his father, T.B. West. The house was full of flowers and more than 250 neighbors and friends from Perry. There was no mention of murder in a eulogy that included praise for his service in World War I. While Velma's father was present for the service and burial, her mother stayed upstairs in the house. Velma had no desire to attend the funeral

Prosecutors Seth Paulin and Homer Harper boasted that there would be a true bill from the grand jury, and on January 12, 1928, at 4:05 p.m., the grand jury handed them an indictment against Velma for first-degree murder. It was the first murder indictment ever for a woman in Lake County. If she was found guilty, the judge could sentence her to life in prison or the electric chair, depending on recommendations from the jury.

Velma's chief counsel was a young prosecutor from Geauga County, Richard Bostwick. He began calling her "just a little girl" early on, hinting at the possibility that she was below normal mentally. Bostwick teamed up with Francis J. Poulson, of Cleveland. Poulson had saved another female murderess, Eva Catherine Kaber, from the electric chair. They engaged "mind specialists"—Dr. A.G. Hyde, head of Massillon State Hospital for the Insane, and Dr. G.H. Williams, superintendent at the Newburgh State Hospital—to examine Velma.

Later, attorney George M. Heil, a former *Cleveland Press* reporter, joined the defense counsel. He resigned his position with the paper to join a Cleveland law firm. He had covered several murder trials as a newspaperman, but this would be his first as an attorney.

Velma's attorneys were going to claim self-defense, but they refused to enter a plea at the arraignment and asked the court for ten days to consider entering a plea of temporary insanity. By not entering a guilty or not guilty plea, they signaled that they were prepared to question the constitutionality of a new law that required insanity hearings before the regular trial in murder cases. The judge ordered a not guilty plea entered into the court record and

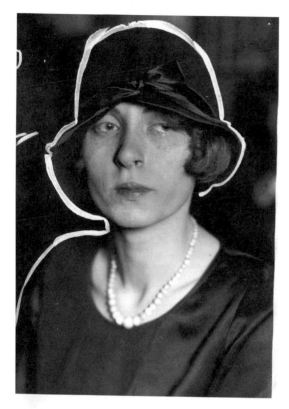

Velma West dressed for court.
*The Cleveland Press Collection,
courtesy of CSU Michael Schwartz
Library, Special Collections.*

granted Bostwick and his team a ten-day period to review the possibility of an insanity plea. He wanted to move ahead with the trial, feeling the validity of the new law could be argued during the proceedings.

In the end, Velma refused to submit to a hearing on capacity, but she was close to a mental breakdown and physically weak. Her attorneys would still claim she acted in self-defense. Their feeling was that there was no witness there to contradict the claim.

Jury selection began on March 3, a Saturday. More than fifty witnesses had been subpoenaed on the state's side alone. The prosecutors had several pieces of evidence: the claw hammer, the bloodstained pillowcase and binding twine. They felt the blood-splattered newspaper would be proof that she sneaked up on her husband from behind. His physical size and strength alone would contradict self-defense. Prosecutors contended that she threw the pillow slip over his head so she did not have to see the effects of the blows. They produced blood pattern evidence on the carpeting, and

they said the body was positioned so that she was between him and the door, leading the investigators to believe she could have run. And finally, she changed her dress, burned the bloodstained clothing after the attack and went to the party.

On Monday, just before the trial began, the prosecution called a conference with the judge and defense attorneys. Sheriff Rasmussen had new evidence. Something kept telling him that there were still loose ends. In one final attempt to get at the whole truth, he had sent a deputy to talk with Velma's friend Mabel Young over the weekend. The deputy questioned her for several hours, until finally Mabel broke down and told him that she and Velma had a lesbian relationship. Could it be that Velma had killed her husband because he was a hindrance to the affair?

The question was a complete surprise to defense attorneys, and it threatened to derail their self-defense plea. During the conference, attorneys for both the state and the defense negotiated, with the judge acting as mediator. In the end, it was a compromise on a second-degree murder plea,

Mabel Young was the hostess of the famous bridge party, as well as the object of Velma's desire. *The Cleveland Press Collection, courtesy of CSU Michael Schwartz Library, Special Collections.*

thereby avoiding the death penalty. Poulson was mindful that Velma had collapsed twice during the proceedings and he feared that a long, drawn-out trial would be injurious to her health.

Prosecutor Paulin revealed for the first time that he had a hard time getting a first-degree charge out of the grand jury, and he was not certain he could prove premeditation in order to get a first-degree conviction from a trial jury. Rasmussen was livid, certain the evidence would speak for itself.

Velma agreed to the plea and was sentenced to life in prison at Marysville. After sentence was pronounced, she and her counsel posed for a battery of photographers, who even asked her to smile.

On her way to prison, Velma was in high spirits. It was the first time she had seen the sun in four months, she said. But her spirits soon faded as she faced life behind bars.

After the trial, photographers encouraged Velma to smile as she posed with the attorneys. *From left to right*: Homer Harper, Francis Paulson, Velma, Richard Bostwick and George M. Heil. *The Cleveland Press Collection, courtesy of CSU Michael Schwartz Library, Special Collections.*

Velma West

Velma awoke on her first full day at Marysville Reformatory for Women in cell No. 8 as prisoner No. 3181. She was assigned to needle class, being regarded by prison matrons as too frail to work in the fields. Her silk dress was traded for a blue uniform, and her fur coat was hung away with other prisoners' "outside" garments. There would be no more rouge for her cheeks and lips and no more cigarettes. Her flapper-style bobbed hair would soon change.

From day one in prison, she looked forward to being paroled. In anticipation of getting out, she took a correspondence course in stenography to support herself. She practiced on a typewriter in her cell.

In 1934, when her chance for parole came up, the odds were against her. The citizens of Lake County were united in an effort to keep her behind bars. She also had been in solitary confinement for using a piece of glass to cut her hair into a boyish style.

By 1939, Velma knew she would never get paroled. In June, she and three other inmates escaped from Marysville with the assistance of a fifth inmate, who slept on a cot in the corridor outside Velma's cell. Velma had access to a key that would open all the doors, but her door needed to be unlocked from the outside. The fifth inmate performed this task. All four escapees were in different cells in different sections of the institution, and their cell doors were apparently unlocked by Velma. They managed to slip through two corridors that were found locked after the escape, so it is believed the fifth inmate unlocked the doors and then locked them after the escape.

Velma left a three-page letter addressed to prison Superintendent Marguerite Reilly on a table beside a picture of Reilly. The picture was inscribed "To Velma West, the girl who made good." In the letter Velma wrote that she was "torn between two fires—my love for Mrs. Reilly and my desire for one little adventure before I die." She also wrote, "I will always hate myself for doing this to you."

State police were notified immediately. They closed off several highways within a fifteen-mile radius of the prison and sent out the alarm on police radio networks, but the women somehow got through the dragnet. Newspapers in several cities would claim sightings of the women.

Superintendent Reilly believed Velma would be the first captured because she had a heart condition and was in failing health. Reilly said she would not be able to keep up with the others, and they would soon leave her behind. Velma's mother made a plea to her daughter to turn herself in.

Velma (left) and convicted robber Mary Ellen Richards escaped from Marysville in June 1939. They were caught in Texas and returned to the reformatory. *The Cleveland Press Collection, courtesy of CSU Michael Schwartz Library, Special Collections.*

A month later, Velma and one of the other escapees, convicted robber Mary Ellen Richards, were found in a rooming house in Dallas, Texas. Velma had been working in a restaurant. The women were brought back to Marysville and probably put in solitary. Reilly threatened to shave the women's heads and feed them nothing but coffee and bread, but evidently that did not happen.

Velma never did get another chance at freedom. When the parole board took another look at Velma's case in 1952, it turned her down again. She died in prison from heart disease in October 1959 at the age of fifty-three.

Chapter 8

Annie George

```
He Would Not Take No for an Answer,
                 Canton
```

If George D. Saxton had one failing, it was his eye for the ladies. Tall and always meticulously dressed, he had a commanding presence and was considerably charming. All were traits that made him attractive to the opposite sex. Once he set his sights on Annie George, a married mother of two children, he would not take no for an answer. Perseverance is often seen as a good quality. But in this case, it was a quality that would cost him his life in 1898.

He came from one of the leading families in Canton. His sister, Ida, was married to President William McKinley. His father, James, was a successful and influential banker who started the *Canton Repository*. Saxton was the only son and, therefore, managed a large estate at his parents' deaths. The money allowed him to accumulate a substantial amount of property, and he was astute at business.

In his fifty years, he had been involved in several serious love affairs. He was engaged four or five times—to one woman twice and to two women at the same time—but never took that final step into marriage. His fiancées came from respectable, well-to-do families, suitable to marry into the Saxton family.

At first he lavished attention and gifts on the young ladies, but as the wedding dates drew near, his devotion would wane, and his interests would

turn to less respectable women, fast horses and his bicycle (called a wheel in that day).

It had rained in the late afternoon of October 7, 1898, and was getting dark fast. Saxton was approaching the steps of Eva Althouse's home at 319 Lincoln Avenue. Eva was his current ladylove. At 6:10 p.m., a woman clad in all black approached him with a gun in her hand. She shot him twice point blank and then walked a few paces away, stopped, turned and fired two more bullets to silence his pleas for help. The woman walked back and bent over Saxton's body, perhaps to check if was dead, and then disappeared into the darkness.

The prime suspect was a jilted lover who had left the security of her husband and home for Saxton. Her name was Anna (Annie) Elizabeth Ehrhart George. Annie and Saxton had carried on a tumultuous relationship for the better part of ten years.

The affair began when the young, dark-haired seamstress was shopping in Goldberg Brothers in downtown Canton and Saxton spotted her. He was so taken with her smooth skin and superb figure that he asked a clerk who she was. "She is a remarkably handsome woman. I will make her acquaintance," he said and managed to get an introduction.

During their first conversation, Saxton learned that she and her husband, Sample George, along with their two sons had come to Canton from Hanoverton, Ohio. He was charmed by her innocence.

A few days later, she received a letter informing her that he had arranged for an apartment for her and her family in the Saxton block, a building he owned. After Annie's family settled into the second-floor suite, Saxton became a frequent visitor. The Georges were somewhat naïve in believing that his visits were merely to make sure their accommodations were comfortable. This was only the beginning of Saxton's campaign to capture Annie's affections.

On one of those visits, Saxton brought a pair of sealskin gloves for Annie to mend. He declared that he was so pleased with her skills at mending the gloves that he brought her a ladies' sealskin coat to alter. It was for a friend in a distant city, he told her, and that friend was about her size and build. When the alterations were finished, Saxton asked her to try it on. She gracefully slid into the jacket and modeled it for him. Saxton said she looked so beautiful in it that it would be a shame for her not to have it. Sample and

Annie were poor compared to George Saxton, so they were flattered, if not a bit perplexed, at his generosity and interest in their welfare.

Saxton's visits became more frequent and included times when Annie's husband was not at home. Saxton was so charming and adept at complimenting her that in spite of the love and commitment she had for Sample and her boys, she finally fell for him.

Annie and Saxton began taking strolls together and were seen in the street and other places. It began to dawn on Sample that there was more going on than a mere friendship. He became suspicious and told Annie to have the visits stopped. She promised she would, but this only fueled Saxton's desire. He enjoyed the effort, the thrill of the chase. Annie was a conquest, and he was determined to win her.

Annie tried to break it off several times. She pled with him to let go, leave her alone. The George marriage was in trouble. Sample was jealous and had threatened to divorce her. Still Saxton pursued, and deep down Annie knew she could not give him up.

Finally, Sample went to talk to Saxton and asked him to stop seeing his wife. Saxton denied that his relationship with Annie was illicit, and he promised that his visits to their suite would stop. It was a promise he never intended to keep, and it was too late for Annie. Her affections belonged to Saxton.

By February 1892, Sample George had had enough. He separated from Annie and filed a $20,000 lawsuit against Saxton for alienation of affections. Sample asserted that Saxton engaged in adulterous behavior with his wife.

Saxton knew he was guilty and that it probably could be proved. He and his attorney began to form a defense of general denial, and Annie was at his side to help prepare for the case. Canton's public looked forward to the lawsuit. It was the next chapter in the George Saxton–Annie George affair.

Annie dearly wanted to marry Saxton. At his suggestion, she went to Canton, South Dakota, and took up residence for a six-month period to give the court there jurisdiction to grant a divorce. He paid all her expenses and attorney fees. She gladly left everything behind for South Dakota, certain that when she returned, they would be married. When he was not visiting, he wrote her endearing letters to which she would reply.

But once she was safely shipped out west, he had time on his hands. He got bored and sought other female companionship. Once Annie's divorce was granted in South Dakota, she returned to Canton with the expectation

of a marriage proposal. Instead, she found that Saxton had grown tired of her. He was distant and cold and he avoided her.

She had left a secure home with a loving husband to be with this man. Now, her reputation was in shreds. Her friends had no time for her. Her life was in ruins, and her anger began to build. She could not believe that he would cast her off like an old worn-out coat—not after she had given up so much.

In retaliation, she filed a $30,000 breach of promise lawsuit. Saxton evicted her from her suite in the Saxton block, so she moved to another apartment. Much of her furniture and household goods were left behind. She claimed that he would not allow her in to get her possessions, so she filed a replevin to recover her property. In Saxton's answer to her breach of promise lawsuit, he claimed that he had never promised marriage. As to the replevin action, he declared she still owed rent on the apartment that he owned.

Annie was desperate by this time and obsessed. She paid unwanted visits to Saxton's office and living quarters, interfering with his business and his love life. She especially wanted to interfere with any intimate moments he might have with other women. She even threatened violence against his lovers. She watched his every move.

In December 1895, Saxton filed for a restraining order. He claimed that she had no legitimate business in his building. He stated that she would come and sit in his office and not leave when she was asked. On one occasion, he called the police.

Annie denied the charges and answered with a petition alleging that the building was used for gambling and prostitution. She stated that her furnishings were still in the building and she wanted to protect them from his lascivious activities.

By now Saxton had fixed his amorous attentions on Eva D. Althouse, a widow of dubious past. Her first husband, having a notion that she might be unfaithful when he was out of town, hired a private investigator to keep track of her. One evening while husband number one was away, the detective found George Althouse, who became husband number two, hiding in the bathroom, absent his clothing. The lady was wearing a robe. She married Althouse after her divorce from her first husband. Althouse met his end in a bicycle accident sometime later.

One evening Saxton and Eva were riding their bicycles when Annie appeared. She was livid at the sight of the two of them together. She pulled

a revolver and compelled Saxton to leave Eva. She threatened that if he did not marry her, she would kill him.

"If I should hang the next day," read a quote from her in *Canton's Greatest Tragedy*, "I know that I would not be blamed if the people knew how I had suffered at the hands of this man."

Eva filed for her own restraining order, and this time Annie was forced to furnish monetary security.

By that time Annie had given seven years of her life to Saxton in one way or another. The scandal grew with each new public act, and the litigations dragged on.

Saxton recognized his vulnerability in Annie's husband's case right before it came to trial. He had been counting on Annie's testimony, but he learned that she was talking with her husband's lawyers. It was time to mend fences with Annie. This was only too easy to do. He renewed his promise to marry her. Annie was thrilled at the prospect of getting back together with him, and she gladly stood by him through the lawsuit and withdrew the replevin. In return, he agreed to give back her belongings. She was happy again.

Saxton took her on a short trip to Pittsburgh, where they came to an agreement on Annie's breach of promise suit. It was settled for a small sum (later found to be one dollar). He promised to have the restraining orders lifted at his own cost.

The only legal problem left for Saxton to face was the alienation of affections case with Annie's husband. This was the one he dreaded most. All his friends, his attorney and even the judge advised him to settle. He wanted to avoid any more scandal for his sisters' sake, so he paid Sample George $1,850 and legal costs. Unbeknownst to Saxton, Mr. George, who by this time had moved to Alliance, had remarried but kept it secret even from his own attorney. If Saxton had known about the marriage, he probably would not have paid anything.

Saxton was greatly relieved. When Annie reminded him of his promise to marry her, he told her he could not marry at this time. It finally dawned on her that he was never going to keep his promise. Now she was alone and felt like an outcast. She was out of money with no hopes of getting any. She hoped Sample might take her back, but then she found out he had married. Worse yet, Saxton was back with Eva Althouse.

Police received the call that George D. Saxton, President McKinley's brother-in-law, had been shot by a woman dressed all in black. The city

marshal and three other officers headed to 319 Lincoln Avenue, Eva Althouse's home. Canton physician E.D. Brant joined them at the scene, where a crowd had already gathered. Saxton was sprawled on the sidewalk near the front steps of the house. His wheel was standing at the curb. A satchel containing a bottle of champagne was nearby. One arm was flung across his face, as if in defense. Blood flowed from wounds in his torso. A little flower stuck out of his lapel.

Annie George was a familiar name to police. They were well aware of the tangle of litigations and her threats toward Saxton. Officers arrested her when she returned to her rooms on West Tuscarawas Street about 8:45 that evening. She remained calm and asked no questions, not even when she was told of Saxton's death.

At the police station, she asked for her attorney, but the prosecutor and marshal would not allow her to call him. This was long before the Miranda rights, so they peppered her with questions. As each question came to her, she sat silently, making no reply.

It was noted that there were Spanish needles and burrs stuck to her dress. Witnesses told police at the scene that the shooter disappeared into a lot next to the Althouse home. The bushes on the lot were a close match to the burrs found on Annie's clothing. Dr. Maria Pontius, who was called to search her, noticed a dark substance on her thumb and forefinger of her right hand. Police thought it smelled like gunpowder. Dr. Pontius scraped a minute amount from Annie's hand into an envelope.

Annie remained in a jail apartment set aside for female prisoners throughout the preliminary and grand jury hearings. During the preliminary hearing, Eva Althouse was questioned closely by John C. Welty, one of Annie's attorneys. Eva claimed to not be home at the time of the shooting and stated that she was visiting her mother. Welty, aware of her past, asked about her relationship with Saxton, wanting to know if she had ever spent time in his living rooms and how late he would stay in the evening at her house. Finally, Welty extracted the fact that Saxton had a passkey to her door. She told him that often Saxton would arrive unannounced to "water the plants and feed the birds."

The grand jury returned a true bill against Annie, charging her with first-degree murder. Before the actual trial, the attorneys made several motions that resulted in hearings. Each time, the seats in the courtroom were filled.

Public sentiment was with Annie. Some attendees were outspoken in her favor, while they condemned Saxton.

The trial opened on April 4, 1899. A crowd of people, many of them women, flooded the courtroom as well as the corridors of the building. Standing room only was at a premium.

Seating a jury was difficult because of the notoriety of the case. The attorneys questioned 125 potential jurors, but finally on the fourth day 12 men were impaneled to decide Annie's fate.

The first witnesses to take the stand were the streetcar conductor along the line closest to 319 Lincoln Avenue and three riders. They all saw Annie—or someone resembling Annie—on the streetcar on the night of the murder. Their testimonies all agreed that she got off within a block of the murder scene at about 5:45 p.m., but they did not agree on whether she was wearing black. Each did remember her carrying a dark cape.

Police introduced evidence about the Spanish needles or burrs on Annie's dress, though it was conceded on cross-examination that nothing else incriminating was found on her.

The testimony of Dr. Maria G. Pontius, who conducted the personal search of Annie, revealed that her thumb and forefinger were discolored and that she had scraped a minute amount of the residue from her hand into an envelope. Upon cross-examination, Pontius said to the best of her knowledge it was not gunpowder. The police officers smelled it and thought it was. The judge threw out all testimony about the gunpowder, saying the accused could not be compelled to provide evidence against herself.

A patrolman named Dickerhoof was next in the witness box. He told of how the mayor had directed him to accompany Annie and to be present as she met with Saxton, because she was afraid of him. Dickerhoof said he did not know what the meeting was about. He met her about six o'clock one evening, and she asked him to find Saxton. When he could not, he and Annie waited until they saw a light shine in Saxton's window. Annie appeared to lose her nerve and asked Dickerhoof to come back the next night, which he did, but she failed to show.

William F. Cook, who lived in the Saxton block, was a surprise to the defense. He was deaf and hard to communicate with, but the state drew out his testimony. He claimed to have seen Annie at Thanksgiving time 1896 in the hallway opposite Saxton's room. According to Cook, she held a pistol.

When she saw him, she quickly concealed the weapon in her cloak. He told the state about another time he saw her at Myers Lake lurking behind a tree watching Saxton and Eva Althouse, but she made no attempt to disrupt them. Cook said he saw her with a gun only once.

One of the most controversial witnesses was W.O. Wentz, law partner to Annie's defense team. Called by the state, he tried to claim attorney-client privilege, but the judge ruled that attorney-client privilege did not extend to the planning of a crime.

Wentz related a conversation with Annie prior to the murder concerning her litigation with Saxton. She told him all Saxton's broken promises and how she had obtained a divorce and his empty promise that he would marry her. She said that when her husband's lawsuit was settled, "there will be a funeral or a wedding." She told him she had a .38-caliber revolver in her trunk. She asked what the effect of killing Saxton would have on her husband's lawsuit. Apparently not taking her seriously, Wentz told her she had better wait until it was settled. She asked if it was a good idea to use two revolvers, one to throw at his feet to make it look like self-defense.

Annie's landlady told the court that Annie often talked of Saxton. During one of these conversations, Annie said that after her husband's suit against Saxton was settled, she was going to ask Mayor Rice to go with her to see if Saxton would do anything for her. Annie told her landlady, "If he does nothing, I will shoot him so full of lead that he will stand stiff."

Several other witnesses related threats Annie had made against Saxton and some of his women. One testified she had seen Annie waiting on Eva Althouse's porch when Saxton and Eva rode up on their wheels. Eva ran into the house, and Annie made Saxton leave with her. According to the witness, she saw a revolver in Annie's hand and heard Saxton say, "Who are you? I don't know you. Go away."

Christina Eckroate, good friend to Eva, testified under oath that she saw Annie shoot Saxton. She claimed to have seen the whole thing from her second-floor bedroom through the window screen, even though it was dark out. She said she could see by the light that was in her husband's grocery store downstairs. Cross-examination brought out that the light was in the back of the store. Applause broke out in the courtroom at the contradiction. The witness also admitted to having an opium habit. Several witnesses testified that she could not have clearly seen the street below because there was a tree blocking the view.

Eva Althouse was subpoenaed, but she had fled Canton. The preliminary hearing had been an ordeal for her, and she may have wanted to escape any further scandal. The defense solidly pointed out that the prosecution had chosen not to pursue her.

Next on the stand was an ex–police sergeant named William J. Haler. Two days after the murder, he found the revolver police believed killed Saxton. However, he kept it to himself for three months. A number of reasons surfaced for his delay in turning it over. Some thought he held onto it in order to possibly claim a reward. He was running for city marshal during that period, and he had planned to bring the gun out at the most opportune time. Instead he turned it over during the grand jury proceeding. He said he found it under a culvert. Its chambers were empty and filled with dirt. He was forced to resign for holding onto the gun.

The defense questioned him about his motives for not turning the gun over earlier. They also brought out that the prosecution had sent Haler to Annie's jail cell to tell her he had found the gun. The prosecution thought they could get information out of her. He asked her what to do with it. She told him to go tell her attorney. The prosecution could never prove that the gun belonged to Annie or that it was used to kill Saxton.

Lena Lindeman, Saxton's housekeeper and laundress, was called to the stand by the defense. If she was to be believed, Annie could not have shot Saxton, because Annie had been at her house on South Market that day until 5:30 p.m. When Annie left, Mrs. Lindeman handed over her cape, and she said there was no revolver concealed anywhere in it. She also testified that there was a big crop of Spanish needles and burrs in her yard and Annie had walked through them. Three more witnesses corroborated Mrs. Lindeman's testimony.

To prove an alibi, the defense called two witnesses, Florence Klinger and Ira Howenstine. Both testified that Annie joined them at Mrs. Klinger's home at 6:25 p.m. the evening of the shooting and that nothing seemed amiss in her demeanor.

Annie's attorneys made the most of Saxton's womanizing reputation, detailing the disappointments he had handed a number of women, including others he had promised to marry.

After final argument, the judge charged the jury and put Annie's fate in the hands of the twelve men. It took the better part of a day and into the

next for the jury to come to a decision. After a grueling twenty-two-day trial, she was found not guilty. As soon as the verdict was read, the spectators erupted in cheers. Friends crowded around Annie and congratulated her. She shook hands with her attorneys and then with each of the jurymen.

On April 28, 1899, Annie was free. She soon was invited to speak on women's rights in Pittsburgh, Columbus, Cincinnati, Steubenville and Akron. Although she turned down the Pittsburgh venue, she accommodated the other engagements, which brought as much as $500 a week.

In October 1903, she married Dr. Arthur C. Ridout. It seems as though the doctor was not without his vices. He gambled, drank and was deeply in debt. He had practiced medicine throughout northeast Ohio and in New York. Shortly after settling in Ravenna, he began asking insurance companies if they would pay on a suicide. One company said it would.

On July 21, 1906, after drinking heavily for days, he hanged himself from the gas jet in the upstairs bedroom of their home. Annie never received any of the insurance money. She left Ohio for New York and died of cancer in Brooklyn on June 25, 1922.

Chapter 9

Enola Morehouse

"Baby Farm" in Wayne County

Pregnant and unmarried—scandalous in the early 1900s. Young women who found themselves "in a family way" had to keep out of sight. If they came from a family of means, they went "to take care of a maiden aunt" or care for "a cousin's children" before they started to show. In actuality, they went to a maternity home until they gave birth and nearly always gave their babies up for adoption. Sometimes their boyfriends, who often were married, paid for the trip in exchange for silence, which the young ladies were only too happy to give.

Whatever their story was, some of these unfortunate young women from northeast Ohio wound up at a maternity hospital at 61 Dunham Avenue in Cleveland run by Dr. Cornelius Baker. Upon entering this hospital, they were presented with an agreement to sign. It read: "This is to certify that I gave my child, a baby boy or girl, to Dr. C. Baker and wife for adoption to be placed in a proper home to the best of their satisfaction and that I will release all claim upon my own child."

During a six-month period in 1905, three of these babies were handed over to Enola Morehouse, who ran a "baby farm" in West Salem. Enola had separated from her husband in Lorain and set up a millinery shop in her new surroundings. Dr. Baker and his wife had no signed agreement with Enola requiring her to provide a good home for any of these babies. The babies were only a few days old when she took them.

Baker said Enola impressed him as being a good woman. She was about forty-five, well dressed, motherly in appearance and apparently very fond of children. After all, she had seventeen children who were either foster children or her own.

In November 1905, one of these infants, Ortha Baker, who was less than two weeks old, died under mysterious circumstances. It was the second baby to die in her care.

Enola's "baby farm" aroused the neighbors' suspicions even before the babies died. Mothers in the neighborhood had the impression that Enola was being secretive. When they asked her about the sick baby, she made conflicting statements about his care. She told different stories to different women about how she came to have the babies and where they came from. The women began to question Enola's character, and they feared for how the babies were treated.

When Ortha Baker died, several of the neighbors went to the coroner, Dr. Hugh J. Sullivan, and appealed to him to look into the "baby farm" and the death that had occurred there. Sullivan began asking questions. Enola claimed to have an agreement with the baby's grandmother, but she declined to name the grandmother. She told Sullivan the mother was prominent in society and that the baby was born out of wedlock, hence she would not name names.

Sullivan held a postmortem examination aided by two doctors who had attended the baby boy before he died. During the autopsy held at Leander's Funeral Home, the doctors could find no physical cause for the baby boy's death. They made a thorough examination of all the child's organs. Everything seemed to be in normal condition, but Sullivan, a former newspaperman before studying medicine, was dogged. He removed the child's stomach and a portion of his liver and sent it to the state laboratory in Columbus for analysis by Professor Curtis Howard.

While the results were pending, Enola went to stay with her daughter in Lorain. En route to Lorain on the train, a reporter from the *Wayne County Democrat* conversed with her about the case. She seemed eager to talk to him about it. "I am accused of a horrid crime and may have to fight to prove my innocence," she said. "They say that I have murdered two children but there isn't evidence to prove that."

After talking with the reporter, Enola began talking with other people on the train. One woman suggested that it might not be a good idea to talk so

much about the two dead children. Enola paid no attention. Instead, she struck up a conversation with a woman traveling with a small child. She picked up the child and played with it while she reiterated her story of the deaths of the two children. "Could you believe it? I'm accused of killing those children myself," she said, "and the county coroner has taken their stomachs out and sent them to Columbus for an analysis."

Later on, she told a reporter from a Cleveland newspaper that the people of West Salem were lying about her and if they "do not stay their tongues, I will shoot every one of them down…I tell the world that I am an innocent woman."

Before Sullivan could begin the inquest into little Ortha Baker's death, Enola was arrested on charges of defrauding the United States mail. Government authorities in Cleveland moved quickly and sent a marshal to her daughter's house to arrest her before Sullivan could subpoena her.

According to the postal charges, Enola used the United States mail to order and receive fifty-eight dollars' worth of millinery from the Ohio Novelty & Hat Company of Grafton. She allegedly wrote to the company misrepresenting herself and had the millinery sent to her address in West Salem. The government charged that she disposed of the hats in one way or another and never paid her bill.

A *Wayne County Democrat* reporter approached her about the West Salem case as she was being led off to a Cleveland jail. "If that baby was murdered at my house in West Salem, it was done by someone who was trying to harm me," she said.

The inquest was completed after Christmas, and Coroner Sullivan's findings were lengthy. The most important finding was the report from Columbus. It stated that the baby's stomach contained enough morphine to kill an eight-year-old.

During the investigation, Sullivan found that Enola had taken three infants from Dr. Cornelius Baker's Cleveland maternity hospital. According to Baker, Enola had come to them for another child after the first one died. She told them how sad she was and that she had given the baby a "nice burial."

At first, Sullivan thought the mother of Ortha Baker was Miss Pearl Baker, and then he was led to believe the mother's name was May E. Barnes. Finally, the name Pearl L. Butler surfaced, but when the marshal tried to serve a subpoena at the address given for Butler there was no such person there. He also learned that a Cleveland man, Isadore Wilder, and a Lorain

jeweler named Richards had paid the bills. Both men were married, and it was believed Richards was the father.

After interviews with mothers in the West Salem neighborhood, Sullivan concluded that Enola was not suitable to care for or rear young children. He heard testimony that she was untruthful and her life was "mystified." Dr. D.W. Garver examined the baby and told Enola the baby had been given an opiate of some kind. Garver stated that Enola's face drained of color when he told her this. When he asked what she was giving the children, she became very agitated. She told him Doctor Hands and Mrs. Winslow's soothing syrup. She went flying around the house in anger. Garver further said that little Ortha was improperly cared for. He was not clean, and he slept all the time.

Sullivan looked at the death of the first child, but for some unknown reason, he did not seek evidence in that death. The child's sex was not even recorded. It is known, however, that Enola's neighbors became so alarmed that they called Mayor Wiley of West Salem, who sent for Dr. J.W. Ferguson. He took care of the first sick baby and could not figure out why it was not getting better. Although he visited the baby on the morning of its death, he was not there when it died.

Sullivan was reaching the conclusion that Enola had entered into a conspiracy with others to murder the babies for compensation and to shield those responsible for the births. He declined to name anyone at that point—perhaps because he did not know who the conspirators were. He urged the state to continue the investigation and recommended that Enola be bound over to the grand jury. He placed Enola under a $1,000 recognizance bond.

Enola received the coroner's findings in jail in Cuyahoga County. Her hands trembled as she read the report. She kept repeating that she was in no way responsible for the children's deaths and she had no idea how morphine had found its way into baby Ortha Baker's stomach. "The babe had a doctor's care for some days before its death," she lamented. "I did all in my power to save it."

In January 1906, the grand jury of Wayne County returned a true bill against Enola Morehouse for first-degree murder. The indictment charged her with poisoning Ortha Baker by administering at least one-eighth grain of morphine and that she also gave the child Doctor Hands colic cure and that her intent was to kill the child. The murder charge would take precedence over the postal charge of misusing the mail.

"As heaven is my witness it is an unjust charge," Enola cried to a reporter upon hearing the news. She had been in poor health during the previous week, but jail matrons had not placed her in the hospital, so she lay on a cot in her cell.

She professed to be a victim of conspiracy. "Some time ago, I took a case away from Prosecuting Attorney Carlin and I believe he is trying to even up old scores." She never explained what case that was and said the affidavits in this case were spiteful and the result of ignorance.

"Most of the people down in West Salem have never been ten miles away from their homes and they don't know what life is in the city." She said federal authorities arrested her and put her in jail so she could not testify at the inquest. "The baby died of bronchial trouble. It was not given morphine."

When told of Enola's comment, Eugene Carlin said her charge against him of spite "is the result of her over-charged fancies." He said she might not be guilty of first-degree murder but she was guilty of "unpardonable lawlessness" and for that she should be punished. "Had the Hands colic cure been given to the child in a reasonable dose," he told the reporter, "no harm would have resulted."

The *Wooster Daily News* editor, whose name has been lost in time, went to interview her. He put questions to her and observed her demeanor and appearance as she answered them. She apparently was still ill, but the doctor at the jail said her illness was more a result of worry than any discernable malady. Her gray-streaked hair was neatly combed, but the gown she wore was disheveled. She looked at the editor with alert eyes through gold-rimmed glasses. She said, "If you write anything in your paper that is fair to me, it will be the first article that has appeared in any paper that I have seen that has not done me an injustice."

The editor asked her if she expected to face the judge in Wayne County before being tried for the federal charges. Enola did not know. "All I can do is sit here and wait for whatever the authorities choose to decide," she said. "I am innocent of the federal charge and can so prove just as quickly as I am brought to trial. But it looks as though they intend to keep me here until I die without giving me a hearing."

She back-pedaled on her charge that Carlin held a grudge against her. She said she was "mistaken in the supposition."

Enola told the editor that she had many friends who believed in her innocence, adding that she had always been fond of children. "At West

Salem, when I was taking care of the infant that died, I cared for it as lovingly as a parent would have done."

She blasted the neighbors for being curious, asserting they were too interested in her business. "I use to snub some of the curiosity seekers and that is what led to my trouble." According to one news article, the people of West Salem said Enola was a mischief-maker who made trouble for her neighbors.

While she had nothing good to say about the people of West Salem in general, she reserved her greatest rancor for J.J. Shank, who was her landlord. In December, he brought suit against her to recover $20 in rent, which he claimed she had not paid. She accused him of selling $1,500 worth of millinery goods left at the West Salem address for $70. Her neighbors in West Salem said her claim was false.

In December, Enola wrote a long, rambling letter to Carlin declaring her innocence. Little of it made sense. It was laced with religious references and wrath toward her suspicious neighbors. "I compare them with the soulless of the evolutionists and the Greeks of pagan religion entirely [sic] destitute of the soul of a personal God."

She defended herself by saying she had given the child whiskey, castor oil, sage, goldenseal, quinine and sweet oil. "I gave him castor oil a few times before the same stool was green and he seemed to suffer grate [sic] pain. I greased him with sweet oil and quinine, but I could see he was getting very poor. He was very poor when I got him and I kept him clean, dry and warm."

In February, Dr. Hugh J. Sullivan died unexpectedly. At first it was thought he had committed suicide, but family and friends denied this. Sullivan had been ill for some days. Apparently he got up in the middle of the night and went to his laboratory for medicine. He reached for the bottle and took a considerable swig. In horror he realized he had swallowed wood alcohol and strychnine. Nothing could be done to save him. The forty-eight-year-old doctor died the next morning.

The loss of Sullivan was a blow to Prosecutor Eugene Carlin's case. Sullivan had collected a large amount of evidence against Enola, some of which he had not sworn to or written down. He had also been the chief witness in front of the grand jury. He was going to testify that in fact May E. Barnes was the true mother of the baby and thereby expose a lie that Enola had been telling her neighbors.

One of the tales she told the neighborhood mothers was that the baby came from Lorain and belonged to a Mr. Smith, whose wife had died in childbirth, and he gave Enola the child to raise. One time she said the father worked in a steel mill; another time she said he ran a saloon.

Before her trial, she wrote a letter to Isadore Wilder, who was one of the men who paid the maternity bills. In the letter, she declared her innocence, but she wanted him to send her twenty-five dollars. "I have shealded [*sic*] you and know if you do what is rite [*sic*] by me I will still keep my lips closed. I have refused to tell the parents of the child and if you are wise you will burn this letter, but please do not fail to send me $25 at once."

Prosecutor Carlin was determined to press forward without Sullivan. Then, a few months later, a second prosecution witness died of a heart attack. Leander Porter was the undertaker who had charge of little Ortha Baker's remains and was a witness at the autopsy. He was to testify to certain conditions of the body.

On the morning of the trial, Carlin received a curious letter. It was unsigned and written in what he judged to be a feminine hand. The writer claimed to be a friend to Enola Morehouse but wanted to see justice done. The letter said that Enola had indeed killed the child and also another baby. The writer said Enola had been paid forty dollars for the death of each child. The writer claimed to have gotten this information from Enola's own daughter. Carlin hoped the writer would come forward, but she never did.

The trial started on May 21 with jury selection in Judge Samuel B. Eason's court. When Enola appeared in the courtroom, her estranged husband was at her side. Two of her daughters were also with her. She was pale and drawn. Alarm registered on her face each time Eason explained to a prospective juror that this was a death penalty case. Enola sat with her four-month-old granddaughter on her lap.

In Prosecutor Carlin's opening statement he said, "Mrs. Morehouse had been the mother of seventeen children, eleven of whom are dead. Six girls are living. No male children of Mrs. Morehouse lived."

According to Carlin and his assistant prosecutor, May E. Barnes was found to be Ortha Baker's mother's name. She visited Enola while she was incarcerated in Cleveland. Within days after that visit, Barnes left the state. Prosecutors claimed it was a conspiracy between Barnes and Enola Morehouse to get rid of the child.

Judge Samuel Eason sat on the bench during the murder trial of Enola Morehouse. *Illustration by Justin Campbell.*

A neighbor, Kathleen Felger, was the first witness for the state. She told the court that she saw little Ortha Baker in "full bloom of health" when he first came to West Salem. Later, she saw him dead in Enola's arms. Emma Patterson testified that she saw the child the night before he died. She said his face was blue and he looked "death-like." Both women said the infant was drowsy, making them think he had been given an opiate of some kind.

Dr. Garver testified that when he examined the child and found that he had been given an opiate, Enola claimed she was giving him a patent colic cure. He told her to stop it. At his second visit, he found the infant was still lethargic and under the influence of the opiate. "If you keep on, you'll get into the electric chair," he warned. He also testified that he was present at the autopsy and had seen Sullivan take out the stomach and part of the liver.

Dr. Ferguson declared that he had seen Ortha Baker a short time before the death and that the baby was awake. In his opinion, the morphine did not come from any medication he had prescribed.

Defense attorneys Charles Adams and Ross W. Funck asserted that the state could not clearly establish that the stomach sent to Dr. Curtis Howard, the state chemist, was that of Ortha Baker. Carlin was able to establish a chain of evidence through signed receipts and testimonies of couriers. But a huge hole in his case was the testimony Sullivan would have brought to the stand.

Dr. Cornelius Baker and his wife had been subpoenaed to testify and ordered to bring all records pertaining to Ortha Baker, his parentage and Enola. However, for some reason, they were unable to get to Wooster in time for court.

The case was turned over to the jury on May 30. After sixteen hours of deliberation, they signaled Judge Eason that they had reached a verdict. The jury found her guilty of manslaughter. At first Enola did not respond, but

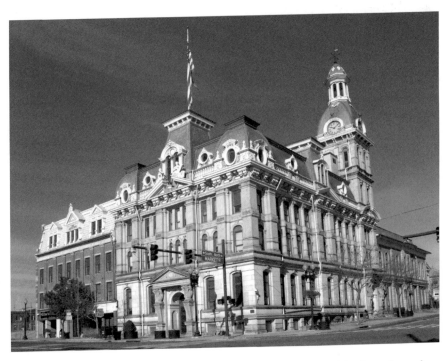

Built in 1878, the Wayne County Courthouse was the scene of Enola Morehouse's murder trial. *Photo by Jane Ann Turzillo.*

a few minutes later it seemed to sink in. She finally collapsed and had to be half carried, half dragged from the courtroom.

Defense attorney Funck filed a motion for a new trial. He cited an error in peremptory challenges during jury selection, a violation of rules in Carlin's opening statement by telling the jury that a first child may have died from poisoning at Enola's hands. He submitted that the verdict was contrary to law and that prosecutors failed to prove that Wayne County was the correct venue.

By this time, public sentiment had grown against the prosecution. Carlin was up against insurmountable odds because of Sullivan's death. Convincing proof had gone to the grave with the coroner. Still, Carlin firmly believed that Enola was guilty. The assistant prosecutor told the *Wayne County Democrat*, "He [Carlin] threw all of his energy and personality in the case and followed his convictions, not only in the face of a deriding defense, but a criticizing public."

On the day of the hearing for a new trial, Enola came to court wearing a pure white dress and pushing a baby carriage containing a six-month-old. The child, like little Ortha Baker, had come from Dr. Cornelius Baker's maternity hospital in Cleveland.

Court records showed that Judge Eason considered the motion for a new trial for several weeks. He finally set aside the verdict and granted Enola a new trial set for December. Eason held that the evidence did not warrant the verdict.

While Enola awaited her new trial, she was housed in the Wayne city jail. Sheriff Armstrong Brown trusted Enola and allowed her to go into town. When the sheriff's wife was out of town, Enola cooked and cleaned for Brown. To further pass the time, she wrote poetry and produced a cookbook.

The second trial did not last long. Dr. Garver, who had been a key prosecution witness in the first trial, was ill with a liver condition and could not testify. Without Garver or Sullivan, Carlin realized he had no case and no other choice but to ask the court to not prosecute Enola.

Enola and her husband resolved their differences, and she returned to Lorain to live with him. The federal authorities apparently dropped their case against her. No record of a federal re-arrest was found.

Enola lived the rest of her life out in Lorain. She died at seventy-two of heart disease on March 28, 1930. One last note: Enola spelled backward is alone.

Chapter 10
"Akron Mary" Outland Woodfield

"Hymie's Heart" Entangled in Cleveland Hit

Mary Alice Chambers always picked the wrong man. Or maybe the wrong man always picked her. Whichever way it came down, in early February 1931, she got caught up in a never-solved murder mystery that made her the object of a four-week, two-state police dragnet. Two men were involved—one a tall, smooth whiskey runner and the other a red-haired Cleveland politician.

"Akron Mary," as the newspapers dubbed her, was in love with "Pittsburgh Hymie" Martin, the whiskey runner. She did not even know forty-five-year-old Cleveland councilman "Rarin' Bill" Potter.

Potter, who had allegedly used his position for a number of questionable city land deals, was found murdered in a Parkwood Drive apartment in Cleveland on February 8. Police had a witness named Betty Gray, who was living in the apartment complex at the time. Sometime prostitute Gray knew Martin from Pittsburgh and fingered him for the hit.

The building superintendent told police he had rented the apartment to a man calling himself M.J. Markus, but he looked just like Hymie Martin. Gray further said that she let Martin into the building when he claimed to have misplaced his key. Police fixed the most probable time of the murder as between 7:15 and 7:30 the night of February 3.

The Parkwood Drive apartment house where William Potter was murdered. *The Cleveland Press Collection, courtesy of CSU Michael Schwartz Library, Special Collections.*

Mary went into hiding after Martin was picked up. Believing she had valuable information on the murder, police began their search for her.

Mary was born June 17, 1903, in Arkansas to Ernest and Pearl Chambers. The family made its way to Akron by way of Louisiana, where younger brother William was born, and Tennessee, where another brother, David, was born. The Chamberses settled on Lloyd Street at first, and Mary's father took a job as a rubber worker. Later, Mary's mother moved to Manchester Road.

Mary had no trouble in attracting the opposite sex. She had naturally dark hair but dyed it red or blond now and then. Her eyebrows were neatly plucked arches over deep blue eyes, and her skin was pale and clear. She was round where it counted and always dressed in the height of fashion, including flesh-colored silk stockings. By the time she was twenty-seven, she had been married three times and had two children.

When she was just fifteen and a popular student at Kenmore High School, she and Eldon Edward Worthman, a rubber worker, were married. They

lived together less than two months when he was arrested. He was released and disappeared.

In 1922, Mary was divorced from Worthman, and she married again. Her second husband was Orland T. Outland. He had a steady job running a meat market. They had two children.

Apparently married life and motherhood proved too boring for Mary. Longing for more excitement, she neglected her husband and children for the loud music of roadhouses and smoky atmosphere of speakeasies. Outland charged that she was keeping company with two other men. Later, friends would contradict that notion and say she was actually a one-man woman.

After five years, Outland filed for divorce and custody of the children. Mary never answered the petition. Instead, she had her eye on a slide trombone player named Harry Woodfield. He played in a theater orchestra and was to become her third husband.

It proved to be another rocky marriage, and Woodfield took up with a wedded blonde. Mary was hurt, but she separated from him and soon was seen in the company of another man. His name was David Wolf, and he ran a roadhouse just west of Akron. Wolf treated the relationship casually, later telling police he had "paid some attention" to her.

It was Wolf who introduced her to "Pittsburgh Hymie" Martin. Friends always said that Mary had to have action, change and variety. Martin certainly could provide those things. He rescued her from her life of mediocrity and jobs working in a beauty shop, the telephone exchange in Akron and behind the desk and cigar counter at the Anthony Wayne Hotel.

Sleek and well groomed, Martin was twenty-eight years old. He had black, slicked-back hair and heavy lidded eyes. There were an estranged wife and three-year-old daughter somewhere in Pittsburgh. At one point during his relationship with Mary, he rented a cottage for his family in the Portage Lakes area outside Akron, but he spent more time with Mary in a rented house in the North Hill part of Akron. Mary began calling him "My Hymie," and she became known as "Hymie's Heart."

Martin grew up in the streets of Pittsburgh, where he learned to be a bootlegger. He made his home there and his money by running hooch from Pittsburgh to Cleveland, Detroit, Akron and Youngstown. It afforded him well-tailored, snazzy suits, fancy restaurant meals and flashy dolls. Though he was well known to police, they considered him a two-bit hood.

"Pittsburgh Hymie" Martin. *The Cleveland Press Collection, courtesy of CSU Michael Schwartz Library, Special Collections.*

"Akron Mary" Chambers Worthman Outland Woodfield. *The Cleveland Press Collection, courtesy of CSU Michael Schwartz Library, Special Collections.*

"Akron Mary" Outland Woodfield

One day, Pittsburgh police tricked Martin into meeting with a couple of detectives, one of them Bernard Wolf, from Cleveland. Martin thought they wanted to talk about some stolen jewelry or a friend of his who was on the lam, so he freely cooperated.

The questioning turned ugly when they told him Cleveland detectives wanted him for the murder of Cleveland councilman William Potter. According to CPD, there was a witness who claimed he rented the murder suite and another who could put him in the apartment before Potter was shot. This was a death penalty case, and Martin knew it. He clammed up and asked for his lawyer.

Police were equally interested in talking with Martin's girlfriend, Mary Outland Woodfield. A third witness who lived in the apartment opposite where Potter was killed told cops she had seen a blonde woman peering out the kitchen window days before the murder. "She stared at me with such intensity that I was startled," she told a *Plain Dealer* reporter. She assumed the blonde was Markus's wife. At this point detectives did not have much of a description of Mary, but now they believed she was blonde.

At the same time, police were looking into Potter's background to see if there were links to Martin or his associates. The flamboyant politician had been accused of selling building materials to contractors who appeared before him on the city zoning board and of taking bribes to facilitate some city land deals. He was indicted and tried on these charges, but while some of his "business" partners did not fare so well legally, Potter rode the winds of luck when it came to convictions.

Before his demise, he was broke from court fights, and he lost his seat on council. There was still one more trial, a perjury charge, to face. It was to start in a matter of days. According to rumor, if he was convicted, he threatened to sing about the participants in a land deal.

Even after all of his legal problems, Potter was a popular figure, and his hometown was clamoring for a quick arrest. Pittsburgh was taking way too long in getting the extradition papers signed as far as Cleveland detectives were concerned. Detective Wolf was impatient and decided not to wait. He and his partner whisked Martin away in a car and drove fast nonstop to the Cleveland Justice Center. The grand jury handed down an indictment soon after Martin's arrival.

"Pittsburgh Hymie" and "Akron Mary" had indeed been in Cleveland on February 2 and 3, but Martin told police he was in Akron at the time

Cleveland councilman William "Rarin' Bill" Potter (right) was the victim of an unsolved murder. Man at left is unknown. *The Cleveland Press Collection, courtesy of CSU Michael Schwartz Library, Special Collections.*

of the murder. His reason for driving to the area was to see how well police patrolled the roads, because he was planning to make a whiskey run.

Cops traced hotel registries in both Cleveland and Akron where the pair had stayed. They figured they had an airtight case, except for one thing: they needed "Akron Mary," and she was nowhere to be found.

Pittsburgh police raided a house in Dormant, where Mary and Martin lived before their trip to Cleveland. The house was empty, but letters Mary wrote to a girlfriend named Joan Lewis had been left behind. Police snatched them up and went looking for Lewis. They found her in Columbus.

Lewis had lived with Mary for three months in an apartment on Cuyahoga Falls Avenue in Akron. While she admitted meeting Hymie Martin, she failed to give them any information on where Mary could be found. They did get a more accurate description of Mary, however. She was not the big blonde they thought. Lewis informed them that she was actually a petite brunette.

Letters in Lewis's handbag bore a signature of "Prudence" but were full of references to "H," which police thought stood for Hymie. They figured

she referred to him that way to protect him. In one letter dated January 29, Mary referred to herself as "being a widow for a week." She apologized to Lewis for not telling her sooner that she and "H" were in Pittsburgh. One letter dated January 10 said: "My H is out of the city at present, so I'm terribly lonesome. You know I love H more each day."

Detectives knew the two women had spoken on the telephone, but Lewis was uncooperative in disclosing what the conversations were about. Calls from Lewis to Mary were traced to two places in Pittsburgh, but when authorities descended on those two spots, Mary had already gone.

Another letter found at the Dormant house was addressed to Mary's current but estranged husband, Harry Woodfield. It was sarcastic, if not hostile in tone. She asked how his "dear little mistress" was. "Isn't it strange how she knocked me for living with another chap, yet she isn't divorced and is living with you?"

Woodfield told police that Mary wrote to him every day. She still called him on occasion and would ask, "Why don't you ditch the blonde and come back to mamma?"

While the letters may have helped police to learn more about Mary, they did little to help them find her. After four days of hunting her with no luck, Akron detective Ed McDonnell began to think Mary had been "taken for a ride." He reasoned that even if she did have something to do with the murder, she would have surfaced in order to establish an alibi for Martin. He also figured there was so much publicity about the case that, if she was still alive, she would have come to Martin's aid.

Cleveland detective John E. Toner dismissed that theory and assembled a list of Mary's favorite haunts. Authorities questioned Mary's friends and learned more about her habits and personality. "Although she's outwardly one of those persons you read of, beneath nice ways she's as hard as nails; in other words, she's hard-boiled," a friend from the past told the *Plain Dealer*. Akron records helped police piece together a life of failed marriages.

Cops collected photographs from Mary's family and friends and distributed them to police agencies throughout Ohio and Pennsylvania. The photos showed her with dark hair, but friends said she changed her hair color overnight.

In the meantime, Pittsburgh detectives were talking with their shady informants, coaxing them to put out feelers for information on Mary. So far, their efforts had turned up nothing.

Finally, Pittsburgh officers caught a break. They found a hotel apartment in Squirrel Hill, a residential section, where Martin and Mary stayed for three or four days after Potter's body was discovered. Mary had fled that hotel just three hours after Martin was arrested. The hotel manager identified photos of both her and Martin. He told police they had registered as H. Martin and wife of Akron, Ohio.

Mary was in such a hurry to get out of the hotel that she left her clothing behind, as well as some of Martin's. The manager put it all in a storage room. A police search of their belongings turned up towels from hotels in Cleveland and Steubenville. One of the most curious things Mary had abandoned was her prayer book, and most interesting to police was a small notebook with two or three addresses. The couple did not go out much, according to the manager. A couple of young men, who looked like racketeers, were their only visitors.

Right before Mary left the hotel, she called the desk and asked to have the bill ready and said she would be right down to pay it. She never appeared. There was a back entrance, so she probably slipped out without anyone seeing her. The manager was sure she had not gone out through the lobby.

The next morning, the manager saw Martin's picture in the newspaper in connection with the murder. He did not call police because he did not want his hotel involved in any scandal. He told the *Plain Dealer* he was surprised that Mary would be involved in a murder. "She wasn't a girl you'd look at closely. She was quietly dressed and said little. She wasn't loud or assertive."

The manager asked police to tell Mary if she was still in the area that she should stop in and pay her thirty-five-dollar bill.

The two lovers used the telephone frequently while they stayed at the hotel. They made a number of local calls and one long-distance call to Steubenville. Police traced it to a racketeer who, it was later learned, procured plates for Martin's blue Nash sedan. The local calls proved invaluable in tracking down more friends and relatives.

Detectives fanned out to interview family members and collect more photos. They sat on houses of Martin's associates, checking license plates and shaking down known racketeers. They frequented Martin's favorite bootleg joints and gambling houses, but mum was the word. No one knew where "Akron Mary" Outland Woodfield was, or if they knew, they were not saying.

The only information they got was from one of Martin's cronies, a Pittsburgh racketeer named Harry Kaplan. Police figured it was Kaplan who had warned Mary to flee the Squirrel Hill apartment. He denied it but admitted to attending a party at that address.

Once cops got their hands on photos of Mary and descriptions of her, they were not so sure that she resembled the blonde woman seen in the Parkwood Drive apartment kitchen window. They mainly wanted to talk to her in reference to "Pittsburgh Hymie's" whereabouts at the time of the killing.

In the meantime, Cleveland detective Peter Allen was in Steubenville checking on rumors that "Akron Mary" may have fled there from Pittsburgh. Allen questioned a Steubenville bootlegger and a Pittsburgh nightclub proprietor. The men admitted to meeting Mary and a girlfriend at a roadhouse, but they could not remember when. Allen pressed for more information, wanting to know how recent the meeting was. He was told that the four of them went to a second roadhouse and then to one of the men's apartments. They identified photos of Mary.

Allen checked a house in Dormant where Mary stayed with Martin's brother for a short period. Both had fled the house after a liquor raid. Phone records from that house revealed calls to two Cleveland vice resorts.

Photos were shown to taxi drivers, streetcar conductors and especially hotel clerks. Police described her as twenty-seven years old, five feet, four or five inches tall and weighing 120 pounds.

The Cuyahoga County prosecutor, Ray T. Miller, was anxious to learn what "Akron Mary" knew. He told the *Plain Dealer* that if Mary would appear and give him the information he sought, he would guarantee her protection. He stopped short of offering her immunity. Her innocence or guilt would still be an issue.

After a four-week hunt, Pittsburgh received a tip from an undisclosed source that "Akron Mary" was in an apartment on Jacksonia Street, a seedy part of the city. On March 15 about 9:00 p.m., they surrounded the red brick rooming house and broke down the door to Mary's apartment. For the first time, detectives set eyes on the woman who was called "Pittsburgh Hymie's Heart." She was a brunette, not a blonde, and fashionably attired in a green silk dress and flesh-colored hose. A Chinese signet ring graced one of her hands. It bore the initials H.E.M. When asked, she claimed that Martin gave it to her for safekeeping.

She was in the company of two men, David Cohen and Albert Goltsman, friends of Martin. They had been listening to the radio and reading the paper.

She was taken to another room, where she freely admitted her identity. When questioned about the three-room apartment, she said she had rented it in early February and furnished it herself. She further told police officers that she had not been out of the apartment since moving in. She even sent out for a new hat. After a bit, she refused to answer any more questions.

Before the trip downtown to the police station, Mary pulled on a green straw hat and a luxurious fur coat with a white collar.

Photographers were waiting outside police headquarters to get pictures of the elusive "Akron Mary" Outland Woodfield. At first she buried her face, all but her eyes, in her coat collar. "I don't want my mother to see my picture in the paper," she said. At the photographers' insistence, she finally posed, agreeing that it was better to have a recent picture rather than the old ones newspapers were running.

The police questioning lasted well into the night, but she had nothing to say, except that her Hymie "would not harm a fly." She asked for Samuel S. Rosenberg, Martin's Pittsburgh attorney, the only one she knew. Rosenberg was surprised because he did not know her. Before she could speak with an attorney, Cleveland cops arrived to take her to Ohio. Snatching Hymie away from Pittsburgh authorities had worked, so they did the same with Mary. She was quickly put in a car and driven to Ohio

Mary's mother, Pearl Chambers, wept when she heard her daughter had been found. She had her son, Mary's brother David, talk to the newspapers. "Detectives have given us a lot of worry over this case," he said. He also told reporters that Mary had not been home since January 1. Pearl was ready to go to Cleveland to be with her daughter during questioning.

William R. Minshall, Martin's lead defense attorney in Cleveland, was also relieved that she was in custody. He told reporters, "We want her to tell her story for we know it will help Hymie."

Newspapers and visitors had been kept away from Martin, so he knew little of the hunt for Mary. He contended that she would come forward when she was needed. Finally notified of her capture, he told reporters he was "awfully glad…But that awful name you've hung on that poor girl," he told reporters. "She'll never be able to live that down. I don't think you fellows have been fair with the girl."

"Akron Mary" Outland Woodfield

Mary's mother, Pearl Chambers, and brother David Chambers. *The Cleveland Press Collection, courtesy of CSU Michael Schwartz Library, Special Collections.*

While a crowd waited outside the criminal court building to get a peek at "Akron Mary" Outland Woodfield, she was being placed under $10,000 bond as a witness against Martin. Under questioning, she said she and Martin had been together in Pittsburgh constantly since January 1. Again she asserted, "My Hymie wouldn't hurt a fly."

Police believed Martin's cohorts had "framed" this story while she was staying in the Pittsburgh apartment. Mary claimed she did not read the newspapers, so she had no idea police were hunting for her. "No one told me I was wanted," she said. "I never went out of the house."

Mary became angry when reporters asked about the two men arrested with her. "There weren't any men found in my apartment. They were just at the top of the stairs when the police arrived." She claimed she did not know Cohen and Goltsman, but she did admit that they might be coming to see her.

Mr. and Mrs. Richard Connelly, who owned the apartment house, contradicted Mary. They said the two men had been there before and that

others came and went. The only time they saw Mary leave the apartment was at night.

The stories did not add up. Detective Inspector Cornelius Cody still believed Mary had been a captive, pointing to the two men who were in her apartment. Apparently money was no object in making her comfortable. The apartment had expensive furniture, and Mary had a fashionable wardrobe. It was all purchased with her own money, she claimed, even though she had no visible means of support. Later, when asked if she could come up with her $10,000 bail, she said she would have to pay it in buttons.

Under questioning by Prosecutor Miller, Mary maintained that she knew where Martin was at all times from January 26 through February 1. If he was not with her, she knew where she could contact him.

Mary told authorities she could prove she and Martin were at the Dormant house in Pittsburgh between February 1 and 7 because she had complained about the gas heater there. She was afraid it would explode, so she called the Dormant Police Department. In her statement, she claimed the police chief came on February 3 to check her complaint. The chief remembered the call but not the date, and he could not be certain that the woman he saw there was "Akron Mary." A check of the records found the actual date of the call was February 4.

The state came up with the February 3 registry from the Anthony Wayne Hotel in Akron. Miller said his office had been in possession of the hotel record for some time. It was solid evidence that the lovers had checked in late that evening. Martin caved in when faced with this information and admitted being in Cleveland on February 3.

When Mary was first questioned, she gave the story that she and Hymie had been in Pittsburgh on February 3. But after she was confronted with the hotel registry and found out he had changed his story, she admitted she had lied about being in Pittsburgh at the time of Potter's murder. To get at the truth, Miller tried putting her under oath, warning her of the penalty of perjury. "You don't have to tell me what happens to perjurers in here," she said. "I know." She refused to talk further until consulting her attorney, Edward S. Sheck. She also knew she did not want to go to Marysville prison.

Sheck had a long conference with Mary and emerged to tell the press that she admitted she and Martin were in Akron the night of the murder. He promised she would relate the whole story at trial.

"Akron Mary" Outland Woodfield

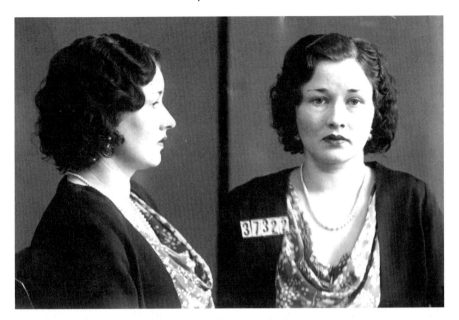

"Akron Mary's" mug shots. *The Cleveland Press Collection, courtesy of CSU Michael Schwartz Library, Special Collections.*

The Potter murder case was front-page news every day. There was strong speculation as to whether the state would use Mary's testimony to place Martin in the area during the time of the murder or whether the defense would use her to provide an alibi. Attorneys on both sides were cautious because she told different stories, and they could not be certain what she might say once on the stand.

A curious public gathered outside the Central Police Station, where Mary was incarcerated in a hospital cell on the fourth floor. The crowds hoped for a glimpse of "Hymie's Heart." The young, attractive woman who had led police on a four-week chase often treated them to a wave from her window.

Ultimately, it was Martin's defense lawyer who called Mary Outland Woodfield to the stand as the first witness. The state had decided it was too risky to use her for a material witness. Mary was stylishly clad in a black velvet dress, black hat, black coat with fur collar and, of course, flesh-colored hose when she entered the courtroom. On the stand, she was visibly nervous, clasping and unclasping her hands. Tears streamed down her face as the questioning began. Sheck stood beside her while she told of how she met

Hymie Martin and detailed the relationship up to coming to Cleveland on February 2. Between answers, she smiled at Martin.

Martin was already in Cleveland, she told the jury. He had sent her money to take the train to come and meet him. They registered at the Auditorium Hotel under the name Mr. and Mrs. H. Chambers and then went to a beer and steak house with a couple that Martin knew. They did not return to their room until very late.

The next day after breakfast, Martin left her with his friend's wife and told her to meet him at four o'clock that afternoon. The two women went shopping and to a movie. When she rejoined Martin, he gave her money to go pay the bill at the hotel. She packed their clothing, paid the bill and took a taxi to the bus station, where she rented a locker for their bags.

About an hour later, she met Martin at the Winton Hotel. They got into a small coupe, drove to get their baggage and then started for Akron. Martin did not exhibit any nervousness on the trip, she said. "He was the same jolly self all the way."

In Akron, they drove to a gas station on Furnace Street where Martin made a telephone call. Abe Kodish met them at the gas station, and the three walked to Valentino's Restaurant on Furnace Street and had dinner.

After Kodish left, the lovers drove to the Anthony Wayne Hotel and registered. The desk clerk recognized Mary from when she had worked there. In their room, Mary tried to call a friend but could not get hold of her. She and Martin went out then and picked up another of Martin's friends at a "smoke shop" and visited a couple of beer joints. They returned to the hotel about two o'clock in the morning and slept until late the next day. After breakfast, they headed back to Pittsburgh.

Under cross-examination, she said she did not know what Martin's business was. He had told her he worked in his uncle's produce business. He and Mary had an agreement: "Never ask me my business and I'll never ask you your business."

Miller hammered Mary, trying to get her to confess that she had been at the Parkwood Drive apartments. She denied ever being there and told the prosecutor that Martin never owned a gun. The state did, however, break down her story that she knew where Martin was at all times between January 26 and February 1.

When her testimony was over, she was free to go. Before she left the police station, she was paid twenty-five dollars for witness fees and mileage. A *Plain*

Dealer reporter asked her where she was going from here. "Home to my mother!" she cried.

Dinner was on the table when she arrived at her mother's house on Manchester Road in Akron. Reporters from the *Akron Beacon Journal* were waiting for her there, but her attorney did the talking. "She is not going back to Cleveland any more to hear the rest of the trial, but intends to stay at home with her mother. She says she is confident that Martin is innocent and will be freed soon."

At the beginning of April, Martin was found guilty of murdering Potter and received a life sentence. Newspapers wanted Mary's reaction. "I am sorry to hear the jury's verdict," she said. "I am certain that Hymie is innocent and as soon as I have permission from my attorneys, I intend to go up to Cleveland to tell him so." Sheck thought it was a good idea for her to stay in seclusion, but Mary missed Hymie, and she wanted to see him.

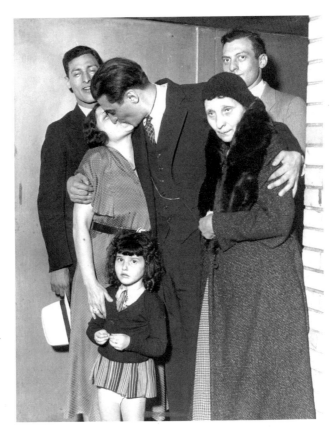

Hymie Martin's family, including his mother, wife, daughter and brothers. *The Cleveland Press Collection, courtesy of CSU Michael Schwartz Library, Special Collections.*

A few days later, she went to Cleveland. Martin's wife and his daughter had visited the day before and were afforded the privacy of the chapel. When Mary went to see him, they were forced to sit in the bullpen. As she was leaving, police arrested her. They released her quickly but told her she would be arrested as an undesirable if they ever saw her in Cleveland again.

Her affair with "Pittsburgh Hymie" Martin ended there. She wanted to leave notoriety behind and fade back into mediocrity.

Martin appealed his conviction and won a new trial. Although Mary did not testify, he was acquitted in June 1932. No one else was ever held accountable for the murder.

Mary filed for divorce from Harry Woodfield, charging him with willful absence. She dropped out of sight but, years later, wound up in Dade County, Florida, where she died on August 18, 1981.

Sources

Akron Beacon Journal.

Akron Beacon Journal Series.

Albaugh, Thurlow K. *Canton's Great Tragedy: The Murder of George D. Saxton.* Wooster, OH: Clapper Printing Company, 1899.

Ancestry.com. *Florida Death Index*, 1877–1998.

———. State of Ohio Department of Health. Ohio Deaths, 1958–2002.

Beaufait, Howard. "1931—The Case of William E. Potter." In *Cleveland Murders*, edited by Oliver Weld Bayer. New York: Duell, Sloan and Pearce, 1947.

Cleveland Press.

Condon, George E. "The City's Greatest Madam." *Cleveland Magazine*, January 1974.

Diedrichs, Gary W. "The Way of All Flesh." *Cleveland Magazine*, December 1974.

Dover Argus.

El Paso Herald Post.

Elyria Chronicle.

Elyria Reporter.

Evening Daily Independent (Massillon, OH).

Evening Independent (Massillon, OH).

Evening Tribune (Marysville, OH).

Family Search Collection: Ohio Deaths 1908–1953.

Flanagan, James B. "Limousines Used to Pull Up in Front of Ardell's on East 84th…" *Cleveland Magazine*, January 1974.

Gifford, Rose. "Mystery of McAdams Family Was Actual Pioneer Days Occurrence." *Ashtabula Beacon*, February 13, 20, 27, 1915.

Grismer, Karl. *The History of Kent.* 2nd ed. Kent, OH: Kent Historical Society, 2001.

Iron Valley Reporter.

Lorain County Reporter.

Massillon Independent.

Official court file in *State of Ohio v. Enola Morehouse*, Wayne County Common Pleas Court Case No. 3655, 1906.

Ohio Democrat.

Olekshuk, Ann. "Cause of Death Unknown." *Star Beacon*, March 20, 1971.

Painesville Telegraph.

Plain Dealer (Cleveland, OH).

Ravenna Republican.

State of Ohio Penitentiary Records, Register of Prisoners.

Thomas, T.J. "The Six White Stones." *World Wide Magazine*, February 1913.

United States Federal Census 1880, 1900, 1910, 1920, 1930.

Warren Daily Tribune.

Wayne County Democrat.

Western Reserve Chronicle.

Western Reserve Democrat.

Youngstown Vindicator.

About the Author

J ane Ann Turzillo writes about Ohio history and true crime. *Wicked Women of Northeast Ohio* combines both. She was one of the original owners of the *West Side Leader*, a large northeast Ohio weekly newspaper, where she covered police news and wrote a historical crime column. She has won several Ohio Press Women awards for fiction and nonfiction and is the author of two historical books on Bath Township and Hudson, Ohio.

Photo by LBJ Photography.

Visit us at

www.historypress.net